Jasper Johns: Printed Symbols

Jasper Johns: Printed Symbols

Introduction by Elizabeth Armstrong

Essays by James Cuno, Charles W. Haxthausen, Robert Rosenblum, and John Yau

Interview with Jasper Johns by Katrina Martin

Walker Art Center, Minneapolis

First Edition

Published in the United States by Walker Art Center, Minneapolis, Minnesota.

Edited by Phil Freshman
Designed by Glenn Suokko

Library of Congress Catalogue Card Number: 89-40803
ISBN: 0-935640-32-0

Note to the reader
With the exception of the Albrecht Dürer engravings reproduced on p. 85, measurements given for works on paper indicate the size of the sheet. Dimensions are in inches; height precedes width precedes depth.

Cover:
Winter 1987
etching and aquatint

p. 2:
Johns working on a print at Simca Print Artists, New York City, 1980.

Jasper Johns: Printed Symbols

•

Walker Art Center
Minneapolis, Minnesota
18 February – 13 May 1990

The Museum of Fine Arts, Houston
Houston, Texas
17 June – 19 August 1990

The Fine Arts Museums of San Francisco
San Francisco, California
15 September – 18 November 1990

The Montreal Museum of Fine Arts
Montreal, Quebec, Canada
14 December 1990 – 10 March 1991

The Saint Louis Art Museum
St. Louis, Missouri
6 April – 27 May 1991

Center for the Fine Arts
Miami, Florida
22 June – 18 August 1991

The Brooklyn Museum
Brooklyn, New York
14 September – 10 November 1991

•

Jasper Johns: Printed Symbols **is made possible by a generous grant from Johnson & Higgins. Additional support is provided by the National Endowment for the Arts.**

This book is made possible in part by a grant from The Andrew W. Mellon Foundation in support of Walker Art Center publications.

Contents

Acknowledgments

In 1988 a gift of more than 240 prints by Jasper Johns was made to the Walker Art Center by Judy and Kenneth Dayton of Minneapolis, providing the museum with the impetus to organize this exhibition. These images, supplemented by other Johns prints in the collection, gave the Walker a complete archive of the artist's graphic work. The museum is extremely grateful to the Daytons for the generosity and acumen that made this collection a reality. We also wish to thank Susan Lorence and Robert Monk for their help in making this acquisition possible, as well as Kenneth Tyler for an earlier donation to the Walker of key prints Johns made at Gemini G.E.L. Together, these extraordinary gifts form the basis of this extensive exhibition.

Jasper Johns' involvement in the exhibition has helped make it more than a retrospective survey. With his support it has grown to include drawings, sculptures, working proofs, and printing elements, all of which offer valuable insights into his creative process. I wish to extend my gratitude to the artist, whose generosity of time and spirit has made working on the exhibition a pleasure. I also thank Sarah Taggart and James Meyer for their assistance during my visits to Johns' studio.

In addition to the artist, who made a number of works available for the exhibition, I am pleased to acknowledge the following lenders: Judy and Kenneth Dayton; the Margo Leavin Gallery, Los Angeles; The Museum of Modern Art, New York; Petersburg Press, London and New York; Stacy and Donna Roback; the Sonnabend Collection; and David Whitney. I also wish to thank the Philadelphia Museum of Art, John C. Stoller and Co., Minneapolis, and Universal Limited Art Editions for their help in securing several key loans.

As this exhibition evolved, a number of Johns' printers, publishers, and dealers shared ideas and information. In this regard, I especially thank Brooke Alexander, Pat Marie Caporaso, Aldo Crommelynck, Bill Goldston, Hiroshi Kawanishi, Carmen Kummer, Susan Lorence, Robert Monk, John Stoller, and Kenneth Tyler. A discussion with Robert Monk early in the planning stages of the exhibition resulted in its focus on print workshops.

The development of the exhibition and its extensive tour would not have been possible without the support of Johnson & Higgins. Their recognition of the importance of the exhibition and generosity in underwriting it are greatly appreciated. The National Endowment for the Arts provided additional support through its Collection Utilization Program.

Numerous Walker staff members have participated in this project. I particularly want to thank: Martin Friedman, for his support and counsel throughout the planning process; Kathleen Fluegel, for her fund-raising efforts; Timothy Peterson, who provided a wide range of administrative assistance; Phil Freshman, for his editorial discernment; Glenn Suokko, who designed the exhibition book; Glenn Halvorson, who photographed a majority of the works reproduced in this volume; Carolyn Lasar and Jane Weisbin, for their tireless attention to the care and handling of this extensive body of art; and Lynn Amlie, Sandra Daulton Shaughnessy, Jon Voils, and other members of our preparation crew, who carefully readied these delicate prints for exhibition. I also wish to acknowledge the able support of curatorial associate Joan Rothfuss, whose help on nearly every phase of exhibition and book preparation greatly facilitated the process.

Finally, I thank the five writers whose contributions have enriched this publication: Robert Rosenblum and Katrina Martin, who graciously permitted us to reprint earlier texts; and James Cuno, Charles W. Haxthausen, and John Yau, who provided new essays. Their diverse perspectives on the prints of Jasper Johns provide fresh insights into the work of this most complex and fascinating artist.

E.A.

Foreword

MARTIN FRIEDMAN

For Jasper Johns, each printmaking venture is an exploration of unknown territory: while a particular theme might be well established in his iconography, he finds little security in the familiar. In addition, as the exhibition *Jasper Johns: Printed Symbols* amply demonstrates, he has an extraordinary capacity for making the techniques of etching, screenprinting, and lithography wholly his own, exploiting their specific attributes to the fullest.

As a printmaker, Johns permits himself to meditate at length on themes richly orchestrated in his paintings. Indeed, the relationship between his efforts in the graphic workshop and in the painting studio has always been close. Not only do his accomplishments in these separate media share imagery, but they also reflect an obsession with expressive technique. Like his paintings, whose surfaces consist of dense, fastidiously applied brushstrokes, his prints reveal a process of accrual, as one textured area overlays another.

Even though Johns' printmaking is as painstaking and methodical as his painting, the graphic workshop affords him more latitude for experimentation with techniques. Through the printmaking process he has been able to "stop action" by examining a particular motif in its various states, often letting these explorations stand as final works in themselves.

The majority of the works in this exhibition have been selected from the Walker's complete collection of Johns' prints—a collection begun with a gift of some seventy examples from the master printer Kenneth Tyler and rounded out in one remarkably munificent stroke by the gift of more than 240 works from the museum's longtime friends Judy and Kenneth Dayton. It is a privilege to present this comprehensive survey, admirably organized by Walker curator Elizabeth Armstrong, of Johns' printmaking achievements.

Introduction

ELIZABETH ARMSTRONG

Jasper Johns' work is layered with levels of subtle and ambiguous meaning. His earliest critics sometimes came to opposite conclusions about the work,[1] and it has been observed that the artist himself "cannot analyze any set of terms in his work without immediately foreseeing the validity of reversing their meaning."[2] Since Johns' first solo exhibition, at the Leo Castelli Gallery in New York City in 1958, his art has continually elicited divergent responses from a wide range of critics who have sought to interpret his paintings, drawings, sculptures, and prints.

Johns has used the printmaking studio to elaborate on themes that recur in his paintings and sculptures: his earliest images of everyday motifs such as flags, maps, numerals, and ale cans were translated into lithography; he later transformed the rhythmic patterns of his "cross-hatch" paintings into evocative screenprints; and, most recently, he has extended his meditations on the four seasons into a series of intaglio prints. In all of these printed images Johns has emphasized the process of making while offering further permutations on his initial thoughts and themes. His fascination with the way in which changes in technique, scale, color, and style alter the form and meaning of the image has sustained his investigation of printmaking, a medium that lends itself to extensive reworking and variation.

Johns' interest in technical innovation has led to a particularly distinctive printmaking oeuvre, which has been documented in many exhibition publications prior to this one. Such notable scholars as Riva Castleman, Richard Field, Christian Geelhaar, and Judith Goldman[3] have taken a comprehensive view of Johns' graphic work. The present volume focuses instead on five specific projects from each of the major print workshops with which he has been associated and around which the present exhibition has been organized. These workshops are Universal Limited Art Editions (ULAE) in West Islip, New York; Gemini G.E.L. (Graphic Editions Limited) in Los Angeles; Simca Print Artists in New York City; and Atelier Crommelynck in Paris, in association with Petersburg Press of London and New York.

This book is divided into five sections, each providing a different perspective on Johns' graphic work as it has evolved over nearly thirty years. The first essay, dating from 1963, was written by Robert Rosenblum as a preface to the artist's first portfolios of prints, 0 – 9 (1960 – 1963), which were printed by Zigmunds Priede at ULAE. It was Tatyana Grosman, the founder of ULAE, who introduced Johns to printmaking in 1960, and his first lithographic markings were of the numeral zero for the 0 – 9 series. In the end, he made three portfolios of ten lithographs each, using different colored inks and a variety of papers. Rosenblum marvels at Johns' ability to invest such commonplaces as the primary numbers, zero through nine, with the "ritualistic beauty, symbolism, and discipline once provided to artist and public by standardized classical and Christian iconography." The essay pays tribute to the highly sensuous quality of the artist's early work, as well as to his obvious affinity for printmaking exhibited in this ambitious and challenging project.

As Rosenblum points out, Johns used a single stone to print the 0 – 9 series. While he erased most of each figure before drawing the next, a vestige of it appeared in the successive numeral print, providing what Rosenblum refers to as the "narrative drama" of the evolution of the stone's image. In addition to the original stone used for the project, ninety-six proofs chronicle Johns' creative process in the early exploration of lithography. The proofs provide a step-by-step look at the progression of the artist's images, revealing his methodical yet improvisatory approach to image-making as he experimented with

various inks, tones, techniques, and papers—including Japanese papers, handmade American papers, French sheets, and even a commercial brown wrapping paper.

In 1968 Johns made his first of many visits to Gemini G.E.L., the print workshop that had been founded by Kenneth Tyler, Sidney B. Felsen, and Stanley Grinstein two years earlier. Under Tyler's direction as master printer, Gemini quickly became known for its interest in industrial fabrication and innovative printing methods. One of Johns' earliest projects there, the Lead Reliefs, entailed the production of wax-and-plaster models executed by the artist; these were then formed in lead on an hydraulic embossing press.

In his interpretation of these tactile works, John Yau compares the artist's use of lead to the materials he favors in his paintings, especially encaustic. Yau argues that lead, which, like encaustic, melts at low temperatures, evokes "the inevitability of dissolution," and he discusses the relationship between this substance and the notion of linear versus cyclical time that he feels underlies these works. At the same time that Yau makes poetic ellipses between the dualities inherent in Johns' materials and themes, he sees these literal and symbolic referents of the Lead Reliefs' motifs as clues to the artist's inner obsessions and concerns. Yau's essay, like the reliefs it describes, is at once straightforward and oblique, suggesting both the dumb facts and the mysteries of our existence.

The third entry in this volume is an interview with Jasper Johns conducted by Katrina Martin for her 1981 film *Hanafuda/Jasper Johns*. Shot at Simca Print Artists over a period of several months, the film shows the genesis of several screenprints of crosshatching images, including *Cicada* (1979), *Usuyuki* (1979 – 1981) and *Usuyuki*

(1980). In the interview Johns talks in literal terms about his attraction to printmaking, noting the opportunity it provides him for repeating the same image in various forms "just to see what happens ... what connects them and what it is that separates them." Working in collaboration with the Japanese master printer Hiroshi Kawanishi, he found ways of softening the hard edges of the medium, giving depth to its usually opaque surfaces. As such tour de force prints as *Usuyuki* and *Cicada* show, he helped transform the screenprint technique into one of lush nuance.

During the same period in which Johns was making printed variations on the crosshatchings—a motif then current in his painting—he was also making prints that returned to the image of the target, one of the first themes he had taken up in his painting. Charles W. Haxthausen's essay examines the etching *Target with Four Faces*, made at the studio of Aldo Crommelynck in Paris in 1979 and published by Petersburg Press. In Haxthausen's view, this print has less to do with the artist's inherent interest in the target per se than in his interest in reworking earlier themes and exploring the ways in which prints function as signs. As the essayist points out, Johns' prints are almost always based on his works in other media; in this case he revives one of his first mature works, the painting *Target with Four Faces* (1955). But does he revive the earlier work in the sense of embodying its original meaning, or does he illustrate it to very different ends? Haxthausen takes his study of *Target with Four Faces* as an opportunity to analyze Johns' work from a semiotic perspective. Examining the symbolic nature of the target and other recognizable motifs in the artist's paintings, he explores the way in which the prints become icons of the unique works. In his discussion of the importance of translation and transformation in Johns' art, Haxthausen also considers the effects of the temporal distance

between the two *Target with Four Faces* images—separated by twenty-four years—on the print.

In the concluding essay James Cuno looks at developments in the artist's work of the 1980s, particularly his use of iconography in The Seasons series. Working at ULAE, which has been directed by Bill Goldston since Tatyana Grosman's death in 1982, Johns has pursued this theme in a series of intaglio prints. His interest in the four seasons is viewed by Cuno in the context of earlier traditions of representation in Western art. The rich combination of personal, cultural, and art-historical references represents a significant departure from the artist's earlier work. For the first time Johns portrays the full human figure, rather than just the fragment of a figure, which, Cuno notes, undergoes a conspicuous metamorphosis in the various Seasons prints. It is in this prominent figure that the writer finds the most profound meaning in the work. Ironically, just as Rosenblum, in the opening essay, reflects on the irrelevance of traditional themes to a young Jasper Johns, Cuno, in this final essay, considers the older artist's preoccupation with the past and the leavening of his stock of images with an increasingly intricate and personal iconography.

1 See Leo Steinberg, *Jasper Johns* (New York: George Wittenborn, 1963), p. 8.

2 Max Kozloff, *Jasper Johns* (New York: Harry N. Abrams, 1974), p. 9.

3 Among the many studies of Johns' prints, the following provide in-depth coverage: Richard S. Field, *Jasper Johns: Prints, 1960 – 1970*, exh. cat. (New York: Praeger and Philadelphia: Philadelphia Museum of Art, 1970); idem, *Jasper Johns: Prints, 1970 – 1977*, exh. cat. (Middletown, Conn.: Wesleyan University, 1978); Christian Geelhaar, *Jasper Johns: Working Proofs*, exh. cat. (Kunstmuseum Basel, 1979); Judith Goldman, *Jasper Johns: Prints, 1977 – 1981*, exh. cat. (Boston: Thomas Segal Gallery, 1981); and Riva Castleman, *Jasper Johns: A Print Retrospective*, exh. cat. (New York: Museum of Modern Art, 1986).

ULAE: 0 – 9 Portfolios (1960 – 1963)

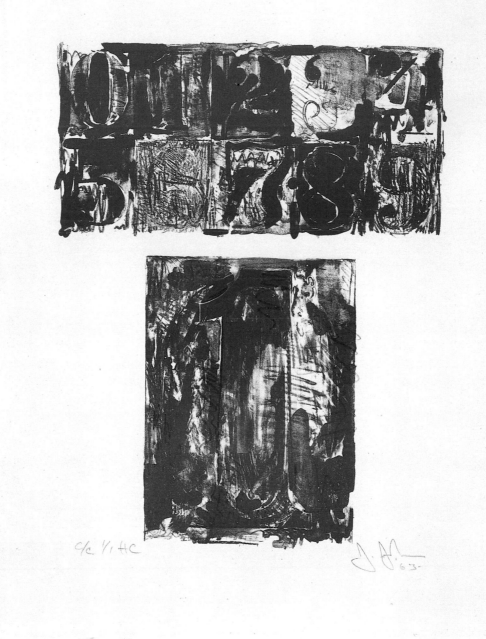

c/c 1/1 HC J. Johns
 '63

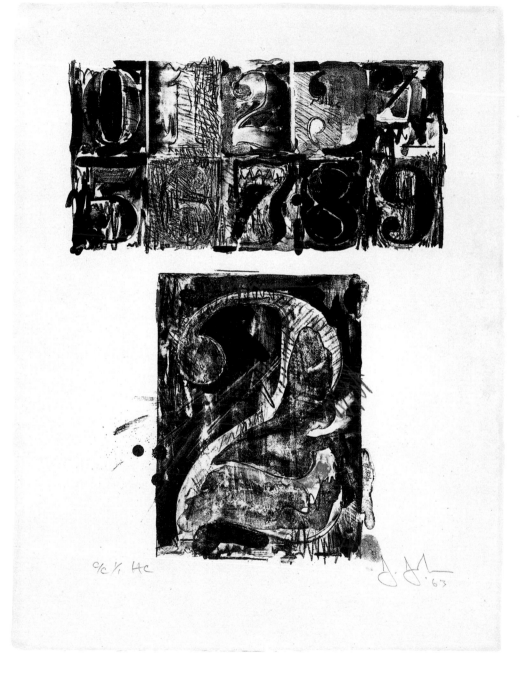

c/c¹/₁ HC J. Johns '63

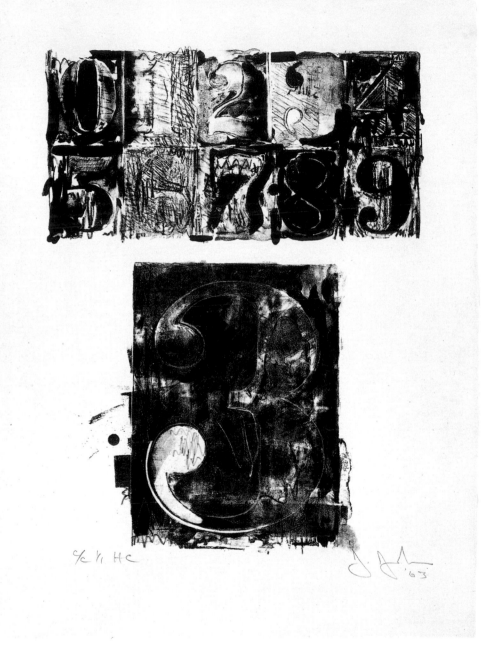

c/c 1/1 HC

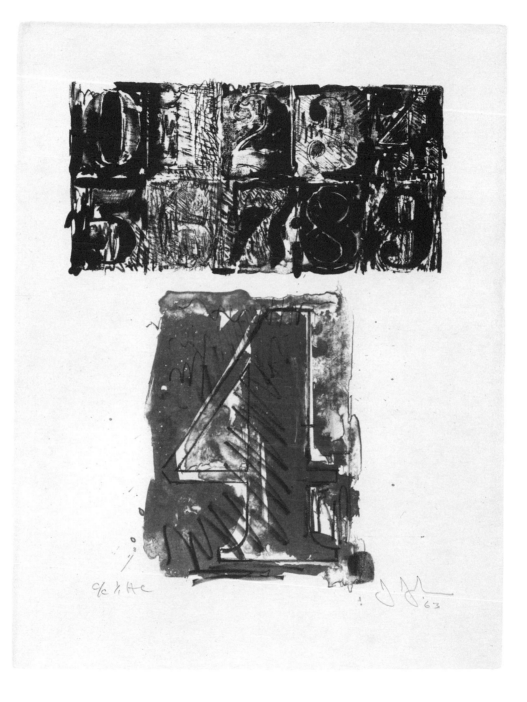

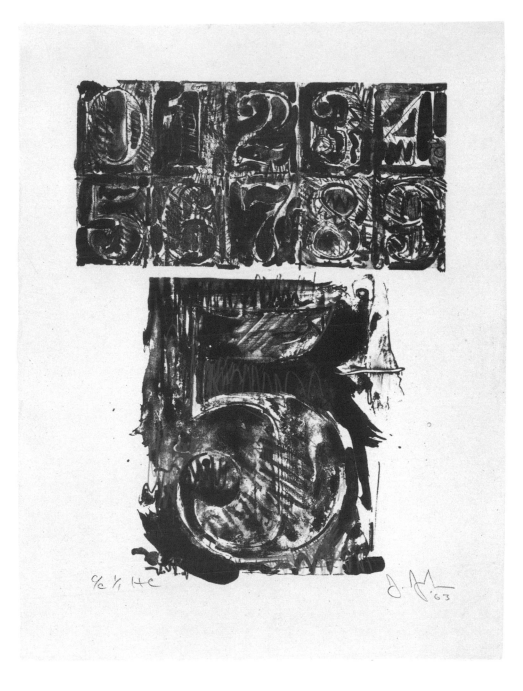

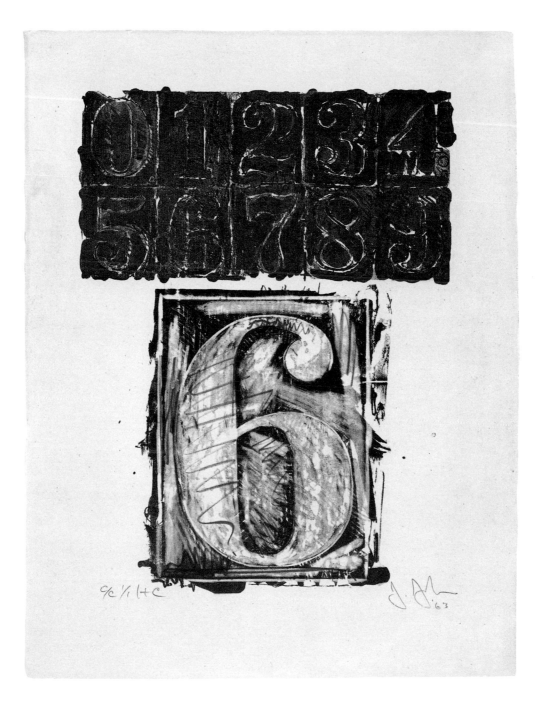

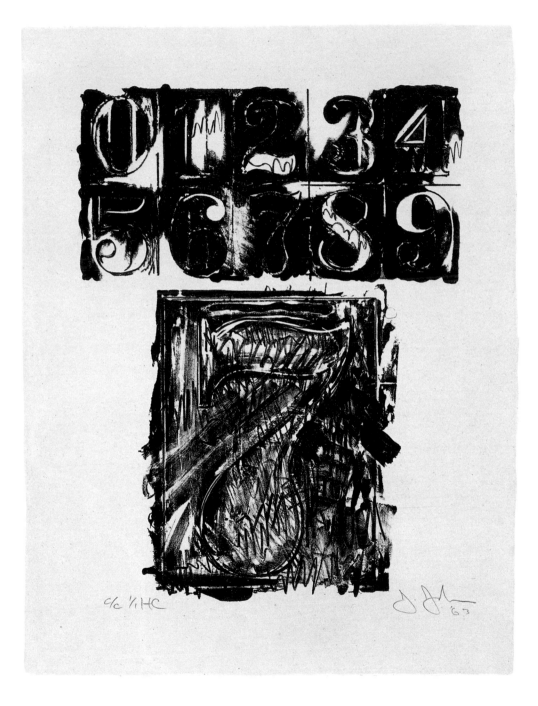

c/c ¹/₁HC

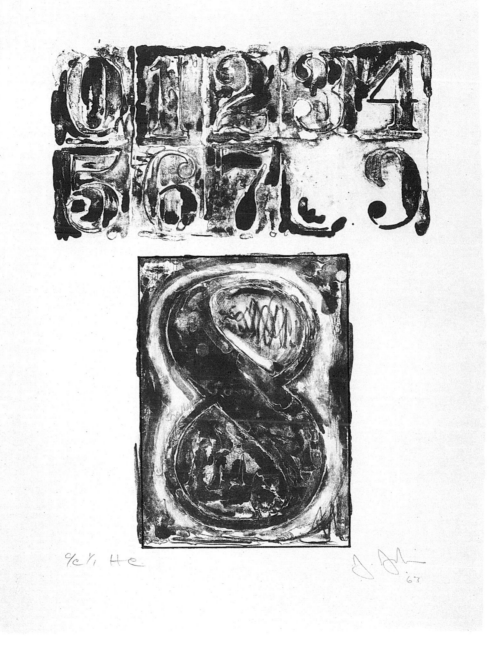

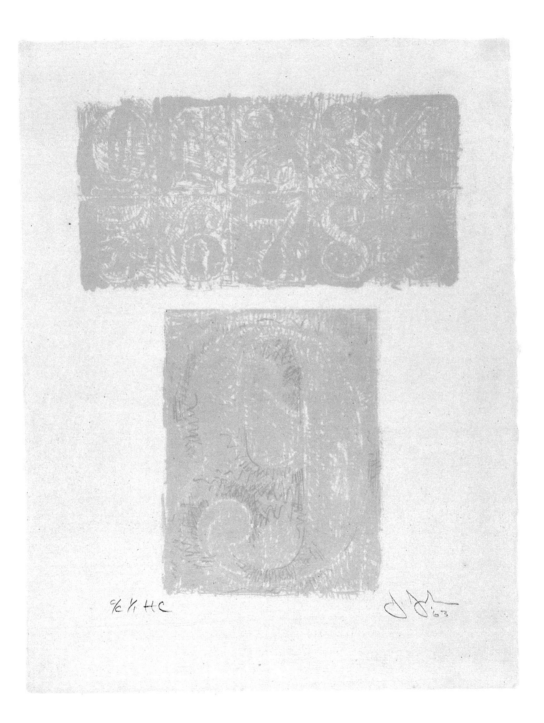

c/c Y₁ HC J. Johns '63

Jasper Johns: The Magic of Numbers

ROBERT ROSENBLUM

Modern art, with modern civilization, has continuously sapped our faith in the great classical and Christian themes to which the old masters paid continuous homage. For Cézanne, mountain landscapes and still lifes become the vehicles of reverential passion that artists of an earlier century would have reserved for the Madonna and Child or a noble Greek myth; and by now, in the mid-twentieth century, this unwillingness to accept a traditionally prescribed subject matter has gone so far that even Picasso's or Matisse's favorite themes may often seem to us as remote as Christ or Hercules. Today, in fact, most major artists have eradicated entirely such explicit references to a shared and identifiable subject; but of those who have reintroduced elements from a nonartistic world, none has done so more imaginatively and more successfully than Jasper Johns.

Like his paintings of flags and targets, numbers and letters, the lithographs presented here heroically attempt to find again those qualities of ritualistic beauty, symbolism, and discipline once provided to artist and public by standardized classical and Christian iconography. To do this, Johns has sought out new mystery in a subject so familiar that we are at first startled to see such exquisite visual attention lavished upon it. The timeworn series of numbers, 0 through 9, which we had come to think of only as a means to useful mathematical ends,

is thus rediscovered by Johns as a fascinating system whose predetermined forms and sequence, like those of the alphabet, may inspire complex aesthetic and intellectual meditations. Of the variations Johns has played upon a theme at once so commonplace and now, thanks to him, so magical, these lithographs are surely the most elaborate. In the first place, the complete numerical series— 0, 1, 2, 3, 4, 5, 6, 7, 8, and 9—is ordered into two rows of five digits apiece at the top of each print, like a constant reminder of the theme that dominates the whole and the parts; whereas beneath this double-row, one digit at a time is singled out for special scrutiny.

But even more extraordinary are the technical means employed. Because the drawing on a lithographic stone can be revised either minutely or extensively for a new printing (or even effaced entirely), Johns conceived the remarkable idea of printing the complete series of ten lithographs from drawings made sequentially on the same stone. The first drawing, 0, was made in the summer of 1960, but the series was not resumed until the summer of 1963. At that time, the initial drawing was printed and then altered for the next lithograph in the series, which honors 1. This in turn was altered for the third print, 2, and so on, until the series came to its inevitable completion with 9. Thus the lithographs represent a series in time, like a measured, documentary record of artistic

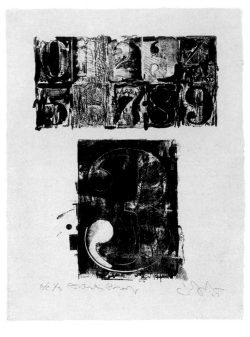

growth. Each print, with the necessary exception of the first, bears the marks of its predecessors, until finally, *9* offers the accumulative totality of the entire series. In this, the whole creates a compelling combination of permanence and change—permanence in the constant and predetermined numerical and visual pattern and, even technically, in the repeated stamp of the lithographic stone's irregular edge in all the upper left-hand corners; and change, in the passage of the artist's hand over each altered drawing, rearranging shapes, contours, values that nevertheless continue to reverberate throughout the other images of the ten-part sequence.

But the richness of Johns' invention does not even stop here; for each drawing was also printed in three ways, with three kinds of ink and on three kinds of paper. The first set, A, is in black ink on off-white paper; the second, B, in gray ink on unbleached linen paper; and the third, C, in a sequence of ten colors and noncolors (yellow, green, blue, violet, red, orange, brown, black, gray, and white) that recall, like the ten digits, Johns' attraction to listing a complete and fundamental series, whether it be alphabetical, numerical, or chromatic. Thus, three times ten different lithographs have been made from the same stone, a procedure that creates the haunting internal relationships of mirrors that reflect each other. Each of the thirty prints not only belongs to its own port-

folio of ten lithographs but to the triplet group, formed with the other two portfolios, that reproduces the identical image in different ink and on different paper.

The intricate order, as tedious to explain in words as the variations of a twelve-tone row in serial music, is quickly perceived, if not quickly fathomed, in the lithographs themselves, which provide not only one of the most dazzling demonstrations of technical virtuosity in modern graphics, but one of the most exhilarating visual and intellectual adventures in recent art. Like so many of Johns' paintings, these lithographs set into tension an underlying schema of bold, flat, and standardized forms— here the simple stencil design of numbers—against the subtlest handicraft of the artist. If the given data of the numbers are inflexible in pattern and sequence, the aesthetic means that define them are of a bountiful freedom. The observant spectator will be struck, for instance, by the sweeping range of light values that run, characteristically for Johns, an all-encompassing gamut from the somberest blacks to the most luminous whites. Thus, in changing from *3* to *4*, the dark layers that enshroud the large 3 are suddenly lifted in the large 4 to produce an effect of startling whiteness and openness that again reaches its antithesis in the growing opacity of black, gray, or brown ink that clogs the upper numerical series in *6*. The intermediate light values are no less remark-

able; for the oily density of the lithographic crayon—the counterpart of the encaustic Johns often prefers in his painting—permits the artist all manner of marvelously twinkling phenomena, like night skies that become unpredictably lighter and darker before our eyes. In the same way, Johns' calligraphy offers a diversity that endlessly enhances the simple numerical themes it describes. Indeed, almost the entire pictorial vocabulary of Johns and even of most recent American art is recapitulated in these prints. Thus, in *4* alone, one can find the tidy hard-edged pattern of the digit itself; an impulsive linear scribble that alternates between the jagged and the fluent; soft and filmy overlays of luminous planes; and the unique, whorled stamp of the artist's thumbprint (echoed throughout the series), a kind of vigorous signature that recalls Pollock's paint-smeared handprints in his *Number 1, 1948* (1948). Elsewhere, as in the drawing of the large *2* and *7*, the calligraphy can become almost explosive: the diagonal movement of these digits' cross-bars seems to generate sweeping rhythms and even sputtering blots and blurs.

But above all, the inexhaustible richness of these lithographs lies in the step-by-step unfolding of this ten-part narrative drama, which becomes a metaphor for the organic disclosure of the artistic process itself. Alternatively slow and rapid, studied and impulsive, tender and robust, the artist's gradual changes leave their steady traces on each print until in *9*, the last and most beautiful drawing in the series, all movement and indecision come to a hushed and immutable conclusion. In the first portfolio, A, all the lithographs are resolved into a profound and ultimate blackness; in the gray series, B, the same forms become a chilly, funereal stone; and in the colored series, C, the chromatic range finally expires, after passing through black and gray, in an almost invisible white that, like a ghostly afterimage of the entire work, hovers unforgettably in our mind and eye.

Robert Rosenblum, professor of fine arts at New York University, has written on a wide range of art-historical subjects. His most recent books are *Paintings in the Musée d'Orsay* (1989) and *The Romantic Child: From Runge to Sendak* (1989). The essay reprinted here was written in 1963 and issued with the 0 – 9 portfolios.

Gemini G.E.L.: Lead Reliefs (1969 – 1970)

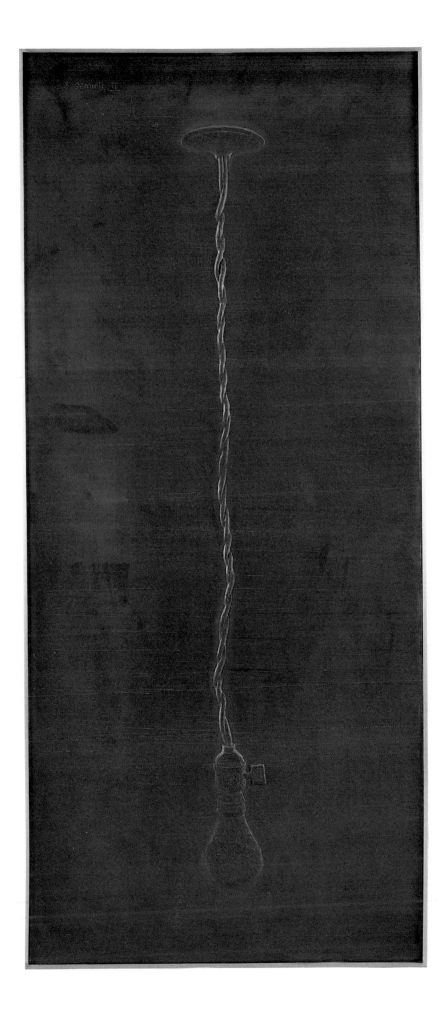

Encaustic and Lead in the Work of Jasper Johns

JOHN YAU

I

It is very likely that the materials (encaustic, plaster, and newspaper) Jasper Johns began investigating in the early 1950s suggested to him the symbols (flag, target, and numerals) that he would incorporate into his work in 1954 and 1955. One could say that, with the first flag painting, Johns began conflating his materials with symbols so that each told him something about the identity of the other. Moreover, it is compelling to see the subject of the dialogue between material and symbol as his way of investigating such themes as the relationship between the self and time.

In the painting *Target with Four Faces* (1955, p. 68), for example, Johns used three materials to achieve three symbolic states. He covered the ground of the work with a collage made of pieces of newspaper; used encaustic to depict the target, while preserving the newspaper collage; and made four plaster casts of the lower portion of a woman's face. For Johns, these materials were not conduits for an idea or for self-expression; and he did not use them to aim for such reassuring pictorial modes as abstraction or mimesis. Instead, it is likely that he investigated their essential properties because of what they suggested about the relationship between the mind and the body, the self and time, the self and others. Johns understood that, in and of themselves, encaustic, plaster, and newspaper were not media waiting to be

imbued with intentions but were specific material facts to be investigated.

Encaustic, for example, evokes three distinct and literal facts regarding the relationship between the mind and the body, between the self and time, between the self and others. It is made of beeswax and comes in a solid form, which must be heated before it can be mixed with pigment. The heat causes it to liquefy. When it hardens it becomes a preservative. Ideally, encaustic exists in either a solid, liquid, or preservative state, and for Johns these states seem to evoke cyclical time, linear time, permanence, and the inevitability of dissolution.

Johns also learned facts about the sources of encaustic that suggested to him the kinds of subjects he could incorporate into his work. Bees, those exemplars of efficiency and economy, gather nectar, which they exude as wax from the underside of their abdomens to make the honeycombs of their hive. In other words, what comes out of the bee's body becomes the body that shelters it, and the bee's wax enters into a social body that renders the bee's individuality insignificant. This literal fact enabled Johns to deepen his investigation of the dualities of identity and anonymity, and of the relationship of those dualities to recognition and dissolution, to cyclical and linear time.

p. 32
Light Bulb 1969
lead relief
edition: 60
39 x 17
Printed and published by Gemini G.E.L.,
Los Angeles
Collection Walker Art Center, Minneapolis
Gift of Kenneth E. Tyler, 1985

By using encaustic to depict the target, Johns was able to integrate an anonymously produced bodily material with an anonymous image. The target (which usually represents a surrogate body one aims at) is familiar to the point of invisibility: identity and anonymity become one. At the same time, he connected encaustic (a preservative) to his realization that one's own identity (even when it is invisible to others) must be defined in order to be seen by the self. By sealing the image of the absent body (a target) inside a bodily material (encaustic), Johns was able to give physical form to his invisibility while permanently preserving it against the passage of time. In doing so, he proposed another view of the artist: rather than being a hero and a person of action, he was a *thing* "which was seen and not looked at, not examined."[1] As Johns has said about himself and his work: "I wanted to know what was helpless in my behavior—how I would behave out of necessity."[2] Throughout his career, Johns has gained further insights into his own "helpless" or limited condition by probing the meanings of the intrinsic properties of materials such as encaustic, bronze, plaster, newspaper, and lead.

When mixed with water, plaster becomes a medium that can be used to make a mold or an impression of an object or a surface. Eventually, it sets and turns into a kind of shell or skin. In *Target with Four Faces*, Johns cast four nearly identical impressions of the lower part of a woman's face. When one looks at the casts, however, it is not clear whether they are of a man's or a woman's face. Rather than being either mimetic examples or abstractions of a face, they are exterior molds offering evidence of something that is now absent. They exist as a sort of external skeleton and also evoke linear time and the constantly aging human body. In placing the casts above the target, Johns not only juxtaposed one kind of preservation (or frozen time) with another, but he also

made an internally produced material become an external skin, and an external cast become a symbol for the internal skeleton.

Johns placed each of the plaster casts in a small compartment. The eyes are hidden because one is unable to see through plaster but is able to feel it clinging to one's skin. At the same time, the nose and mouth—the sites of breathing and eating—are prominently displayed. It is possible to be blind, but it is impossible to survive without breathing air or ingesting sustenance. Moreover, someone who is blind must learn about his or her body through touch rather than reflection. In *Target with Four Faces* there is a tension between the absence of the eyes and the surrogate presence of mouth and nose, between the "blinded" eyes and the absent body. Johns has conflated his "helpless" desire for self-recognition with his helpless awareness of the invisibility of the body.

The newspaper is evidence of a social milieu an individual simultaneously belongs to and is separated from. In reading about this milieu, one "digests" the material in a newspaper but is not sustained by it. Finally, unless one has firsthand knowledge of the situations it describes, the newspaper contains information that is difficult to prove either true or false. The viewer of *Target with Four Faces* can see the newspaper through the layers of encaustic but, finding it difficult to read the words, is led to become aware of his or her isolation from others. Within this isolated, inward-gazing state, the viewer also comes to think about something potentially more disquieting: though the encaustic prevents the newspaper from rotting, it also obscures the "voices" of the newspaper. Thus a state of permanence has been intertwined with states of muteness, isolation, and invisibility. Both linear time and a frozen instant have been integrated. It is compelling to see *Target with Four Faces* as a corpse

that preserves an absent body while expressing both a desire to be recognized and a state of helplessness.

Encaustic, plaster casts, and newspaper are things made, shaped, or used by one who is both a body and a member of a society. Johns' investigations of them result in a reversal. Whereas the plaster and encaustic symbolize a movement from the interior body to an exterior form, the newspaper symbolizes the movement from an external object to "voices" preserved and thus stilled within the body of the work. It seems likely that, within his investigation of the mind and body, Johns associates the newspaper with the mind and that he connects plaster and encaustic with the body. By bringing these materials together to form something that is both a painting and a sculptural object, a surface and a thing, something to look at and something to read, Johns is able to give physical identity to the ruptures separating the mind and the body. Given that his materials and his subject matter are contingent with a lived experience, one could say that Johns combines them in order to deepen his understanding of the dualities of recognition and identity, permanence and dissolution, reflection and invisibility. Seen in this way, *Target with Four Faces* represents the various fissures separating the mind and the body, the self and society.

II

For more than thirty years, Jasper Johns has been examining and reexamining his hoard of homely symbols.[3] He interrupts these factual examinations only when he encounters something public and unowned that contains further evidence regarding the dualities of mind and body, of cyclical and linear time, of permanence and dissolution. Most recently, in what has been a particularly resonant period in his career (1982 – 1989), he has recognized evidence of these distinct, interlocking states in a Swiss road sign, whose German and French phrases can be translated into the warning "Deware of falling ice"; in a trick English vase that includes profiles of Queen Elizabeth and Prince Philip; in a wood-engraving of a whale, by Barry Moser, that appeared in the Arion and University of California editions of Herman Melville's *Moby-Dick;* in Matthias Grünewald's Isenheim Altarpiece (circa 1512 – 1516); in a full-length outline of Johns' shadow made by his friend Julian Lethbridge; and in Frida Kahlo's allegorical self-portrait *What the Water Gave Me* (1938).

Having brought these and other "things" back into his studio—and the artist's vision is rooted in the world of concrete evidence—he uses procedures he has established over the course of his career to examine them. He utilizes different tools and materials, applies various processes, and chooses from a palette consisting of primary and secondary colors and the tonal range between black and white, in order to sift the evidence out of one context and into another. Through the application of these procedures, Johns is able to discover something else about the constant tensions and elusive states he is examining. When he feels that a particular symbol has been made to disclose all it can about the relationship between mind and body, between cyclical time and the constant progress toward complete dissolution, he returns it to his hoard rather than discarding it.

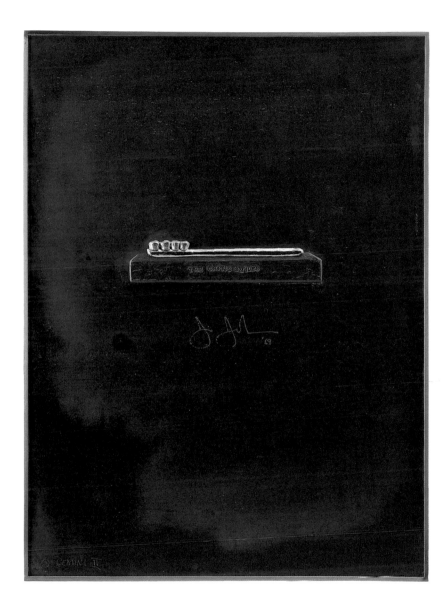

The Critic Smiles 1969
lead relief with cast-gold crown and tin leaf
edition: 60
23 x 17
Printed and published by Gemini G.E.L.,
Los Angeles
Collection Walker Art Center, Minneapolis
Gift of Kenneth E. Tyler, 1985

Johns' sifting preserves the given symbol's essential features and contours. Given his concern with dissolution, it is not surprising that both preservation and metamorphosis are integral to each of his investigations. Whether it takes the form of a monotype, a lithograph, an etching, or a sculpture, the Savarin coffee can is always a Savarin coffee can; and it is always posed frontally, like a silhouette. One of the reasons Johns deliberately circumscribes our ability to scrutinize his work is that doing so enables him to explore the act of recognition, particularly in regard to the dualities pervading one's basic existence.

Johns does not approach cyclical and linear time as abstract themes but as literal facts that are intrinsic to the materials he employs. When he finds worldly evidence that corresponds to these facts, they become symbols in his vocabulary. Typically, each symbol contains some disquieting evidence about a conditional world in which the artist feels divided and incomplete, vulnerable and invisible. Each investigation is further informed by a constant awareness of change and mortality. Caught in this awareness of time, Johns examines his symbols as if, by doing so again and again, he could stop time. The circularity of his work, his insistent probing of previously used symbols, rhymes with his awareness of the relationship between mind and body, between cyclical and linear time. It is along the seams where these states abut and overlap that Johns both finds his evidence and directs his investigations.

Johns' strength lies in his capacity to recognize evidence of duality within a specific and palpable thing he encounters in the world. His provocative sensitivity to tools, materials, and processes has evolved out of his desire to understand the relationship between the mind and the body, while his relentless investigations suggest the degree to which he is compelled to discover all that he can about the self and mortality. Although simple in its design and seemingly familiar in its features and forms, his work stirs us out of the somnambulant state of thinking that we know what art is or should be. We do not look at Johns' work: we see ourselves seeing it.

Bread 1969
lead relief with laminated embossed paper,
hand-colored in oil
edition: 60
23 x 17
Printed and published by Gemini G.E.L.,
Los Angeles
Collection Walker Art Center, Minneapolis
Gift of Kenneth E. Tyler, 1985

III

Johns' Lead Reliefs (1969 – 1970) occupy a singular position in his oeuvre. Evolving out of his exploration of embossing techniques in the prints *No* and *Embossed Alphabet* (both 1968 – 1969), and stamped out on an hydraulic press, these six works are the artist's most experimental efforts in the print medium to date.

Johns understands the relationship between lead and encaustic in terms of factual differences and similarities. Formally, both are media that can be applied, stamped, incised, and shaped. On the one hand, both melt at a low temperature, evoking mortality. On the other hand, lead reflects light rather than allowing it to pass through its "skin." Another essential difference between encaustic and lead is that the former is produced by the body, while the latter is harmful to it. In using lead, Johns widened the scope of his investigation of the relationship between the mind and the body—and discovered another way to address cyclical time, mortality, and the impossibility of transcendence. Moreover, he used the mode of relief not only to articulate the malleability and low melting point of lead but also to explore the relationship between surface and object, skin and body, recognition and dissolution.

While five of the reliefs—*High School Days* (1969, p. 42), *The Critic Smiles* (1969, p. 36), *Flag* (1969, p. 46), *Light Bulb* (1969, p. 32), and *0 through 9* (1970, p. 45)—are reexaminations of symbols he had previously investigated, the sixth, *Bread* (1969, p. 39), represents a subject he has looked into only one other time, in an untitled charcoal drawing of 1969. Since making the reliefs, Johns has not felt compelled to return to "bread," which suggests that he exhausted it of all it could disclose almost immediately. And yet, the question remains: What evidence did he recognize when he first encountered it?

The answer to this and other questions is suggested in Johns' "Sketchbook Notes," which were first published in the spring 1965 issue of the Swiss journal *Art and Literature*. There the artist describes the specific characteristics of two fictive identities, the "spy" and the "watchman," as well as outlines his understanding of the act of recognition: "'Looking' is and is not 'eating' and 'being eaten.'" In equating "looking" with "eating," Johns reveals something about his awareness of time and identity.

Eating is an essential human activity, occurring in both cyclical and linear time. For Johns, the connection between "looking" and "eating" is encaustic; the bee eats something anonymous that exists in the world and then produces wax, which goes into the making of a hive or house. For the bee, eating is connected with identity and the relationship between the single being and society, anonymity and recognizability. In his description of the "watchman" and the "spy"—two anonymous workers—Johns connects looking (or the act of recognition) to eating (to absorbing the specific evidence into his vocabulary of symbols). Like the bee, he makes the "house" he inhabits. The difference is that Johns' "house" or body is haunted by his awareness of mortality, which, in his conflation of *Bread* and lead, is clarified by the relationship he establishes between an impermanent material that sustains the body and a permanent material that simultaneously poisons and preserves it; to preserve the body of this work is to make it a corpse.

Johns describes the watchman as someone who "leaves his job & takes away no information." In other words, he works for someone else; guards someone else's property; learns nothing about either himself or what he protects; is anonymous; and is isolated from the world of things surrounding him. Meanwhile, "The spy designs himself to be overlooked." He, too, works for someone else; investigates other people's property so that he may learn something useful; is, by choice, anonymous or disguised; and is iso-

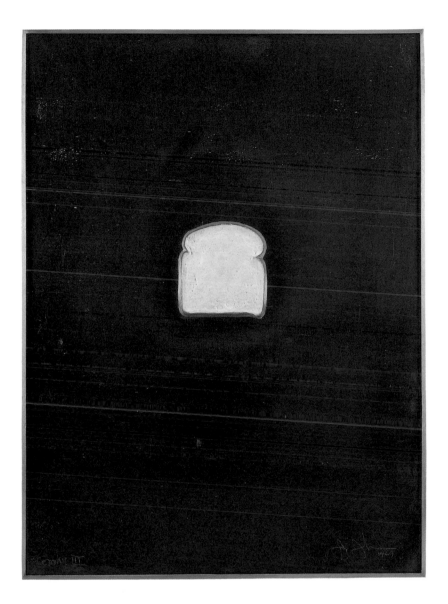

lated from the social milieu he inhabits. The watchman and spy are Johns' symbols of the body and mind. When he reexamined his flags and targets, he at once returned to something he knew and discovered something he did not previously know about the self.

Elsewhere in "Sketchbook Notes" the artist articulates a compositional obsession that has continued to frame the scope of his investigations: "(Cézanne—each object reflecting the other.) That is, there is continuity of some sort among the watchman, the space, the objects." Written ten years after he used encaustic to investigate and preserve the identity of the target and flag, Johns' notes suggest the guidelines his recognition of the relationship between the mind and the body must fulfill in order for him to introduce a new symbol into his work. "Continuity" is his way of incorporating the fissures into his compositions; it also suggests what he may have been thinking about when he began working on multi-paneled paintings such as those entitled *Corpse and Mirror* (1974 – 1975). Although the notes were published four years before he began working on the Lead Reliefs, it is clear from his later work that they established a foundation upon which he could build. "Sketchbook Notes" gave Johns a ledge from which he could survey his past, while providing him with a lens through which he could recognize palpable evidence of the mind/body tension in the world.

IV

In the 1969 drawing that preceded the lead relief *Bread*, Johns acknowledges his sources of information by stenciling a set of initials in each corner: T.W. (upper left); L.C. (upper right); M.D. (lower left); and J.J. (lower right). In the middle of the drawing he has outlined two similiar contours side by side: the outline of a slice of bread and the base of the 1961 bronze edition of Marcel Duchamp's sculpture *Female Fig Leaf* (1950). In addition to evoking Duchamp, Leo Castelli (Johns' dealer), and himself, the artist refers to Trevor Winkfield, an English artist who currently lives in the United States. On the left side of the drawing Johns names the sources of his symbols, while on the right side he juxtaposes the initials of his dealer (the man who makes the artist's work public) and of himself (the person who gives form to his recognition).

From 1968 to 1972, Winkfield, then still in England, edited and published a journal, entitled *Juillard*, for which he solicited and received material from Johns. After seeing a reproduction of the painting *No* (1961), Winkfield asked the artist if the outline in the upper left-hand corner of the painting was intended to represent a piece of bread. In fact, Johns had made the imprint by heating the base of the bronze sculpture, which was in his collection, and pressing it against the painting to melt the wax.

Bread unifies the separate aspects of the divided self. Again: "'Looking' is and is not 'eating' and 'being eaten.'" The watchman looks but does not eat (he "takes away no information"), while the spy eats but must avoid being eaten. (He "designs himself to be overlooked.") The watchman and spy identities enabled Johns to purge the personal and anecdotal from his work. His desire is to explore the self rather than to prove its individual uniqueness.

We cannot eat Johns' *Bread*. However much we might like to consume and thus use what is in front of us, the artist

has made it impossible for us to carry out that action. Although it embodies an extreme state of fragility, *this* bread also maintains an inviolable autonomy. On one level, Johns has conflated anonymity and autonomy. On another level, lead is poisonous, impenetrable, and does not decay, while a slice of bread is an anonymous object we see and eat but which—like numerals, flags, and targets—we do not necessarily look at. By integrating inert matter with something that rots, he has made the relief expose the dual nature of time. Lead, which evokes both permanence and cyclical time, has been merged with bread, which evokes linear time. The white bread protrudes from the rectangular surface, like a featureless face or torso, symbolizing the inherent tensions between recognizability and anonymity, permanence and dissolution, poison and sustenance.

While the drawing acknowledges Winkfield's provocative misperception, the lead relief goes a step further, containing as it does Johns' recognition of the evidence inherent in the misperception. Sifted out of one context and into another, *Bread* is an example of Johns' ability to integrate various dualities—the paradoxical relationship between cyclical time and linear time, for example—into a self-contained thing that is both surface and object.

V

The lead relief *The Critic Smiles* embodies various manifestations of Johns' awareness of the tensions between mind and body, between cyclical and linear time. Reworked from a drawing done in the late 1950s, a sculpmetal model in 1959, and a lithograph in 1966, the relief is of a toothbrush capped by teeth rather than bristles. The work is the result of Johns' recognition of at least three specific facts. First, it suggests that we the viewers are critics who wish to pry into the artist's life. Later, we clean ourselves off and begin again. By replacing the bristles with teeth, Johns has reversed the cycle of consumption. *The Critic Smiles* replaces the fiction that one contemplates art from a pure state with an object that demands an active participation in its impure meanings. Second, the relief embodies the duality of consumption and preservation. In using gold, tin, and lead to make the work, the artist alludes to mortality (dissolution) and perfection. Third, the gold teeth are permanent but nonfunctional. Johns knows he cannot stay time. The single row of teeth evokes the absent mouth and the imperfect body.

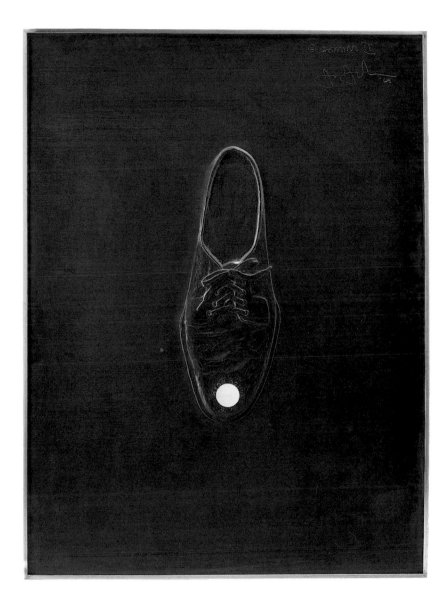

High School Days 1969
lead relief with mirror
edition: 60
23 x 17
Printed and published by Gemini G.E.L.,
Los Angeles
Collection Walker Art Center, Minneapolis
Gift of Kenneth E. Tyler, 1985

VI

In the lead relief *High School Days* Johns once again redirects the inquisitive thrust of our attention and its voyeuristic undertones. Derived from his 1964 sculptural object of the same title, the lead relief subverts our ability to gaze into the work and reduce it to autobiographical anecdote. He first outlined the idea of *High School Days* in a 1963 sketchbook note: "Make Shirl Hendryx's shoe in sculpmetal with a mirror in the toe—to be used for looking up girls' dresses."[4] By sifting this potentially anecdotal fact into the context of a relief meant to be mounted on the wall, Johns is able to evoke the split between mind and body, as well as the harsh truth that neither the artist nor the viewer can halt time. The viewer sees the downward-pointing shoe and his or her face, but not his or her body. Voyeurism— a form of consumption—has been transmuted into a self-regard that is tainted and incomplete. The *High School Days* relief returns the viewer to a state of inward-gazing dividedness.

At the same time, Johns conflates the potential sight of female genitalia with the face, purgation (bodily functions) and creation with seeing. On one level, he reverses the viewer's voyeuristic impulse into a self-regarding act. On another level, the conflation of purgation with seeing evokes the possibility of a simultaneous dissolution and birth of an incomplete self. Lead, which exists in either a hardened or a liquid state, is used to represent the shoe— the absent body—while a mirror is used to reflect the bodiless self. The mind, Johns seems to be suggesting, is always trying to find a way to give birth to a permanent body. In a literal and disquieting way, *High School Days* exposes the paradoxical relationship between birth and dissolution, creation and mortality.

VII

By using lead to preserve the essential features of a light bulb dangling from a cord, Johns negates that object's metaphorical implications. Seen in relief, the light bulb and cord are inseparable from their surroundings. Light, something that we think of as a distinct presence, here becomes a specimen of dead matter in a leaden world. The goal is not light because, for Johns, transcendence is impossible. By conflating the light bulb and lead, his *Light Bulb* presents us with proof that the body will ultimately betray itself and become inert matter.

0 through 9 1970
lead relief
edition: 60
30 x 23 1/2
Printed and published by Gemini G.E.L.,
Los Angeles
Collection Walker Art Center, Minneapolis
Gift of Kenneth E. Tyler, 1985

<div style="display: flex;">
<div style="width: 50%;">

VIII

In *0 through 9* Johns integrates lead and prime numbers. Whereas lead is infused with cyclical time, the numbers evoke infinity and linear time, limitlessness and limits. Beyond this integration of time's dualities, the lead relief also embodies such dualities as definition and dissolution, recognition and illegibility.

</div>
<div style="width: 50%;">

IX

Flag can be said to function as a kind of centerpiece for the entire set of reliefs. In the other reliefs, Johns investigated such polarities as sustenance and mortality (*Bread*), transcendence and inertness (*Light Bulb*), creation and dissolution (*High School Days*), the self and others (*The Critic Smiles*), and cyclical and linear time (*0 through 9*). In the *Flag* relief he has turned his attention toward the relationship between the skin and the body, between the self and anonymity.

On a formal level *Flag* resembles a bas relief, which can be said to be both an incomplete body and a rough-surfaced skin. This lead relief is located somewhere between definition and dissolution. On another level, the artist has absorbed the flag into lead, thus making it achieve a unique identity. It is compelling to see the *Flag* as the analogue of Johns himself in the reliefs; it hovers between legibility and illegibility, which can be read as the artist's equivalents for recognizability and invisibility.

Johns used lead to investigate such paradigms as transcendence (light), infinity (the numbers), unique identity (the flag), sustenance (bread), birth and the self (the mirrored shoe), and consumption and meaning (the toothbrush). Each investigation resulted in a precise realization for him. Consequently, each relief is subtly insistent about the intrinsic facts of its materials.

</div>
</div>

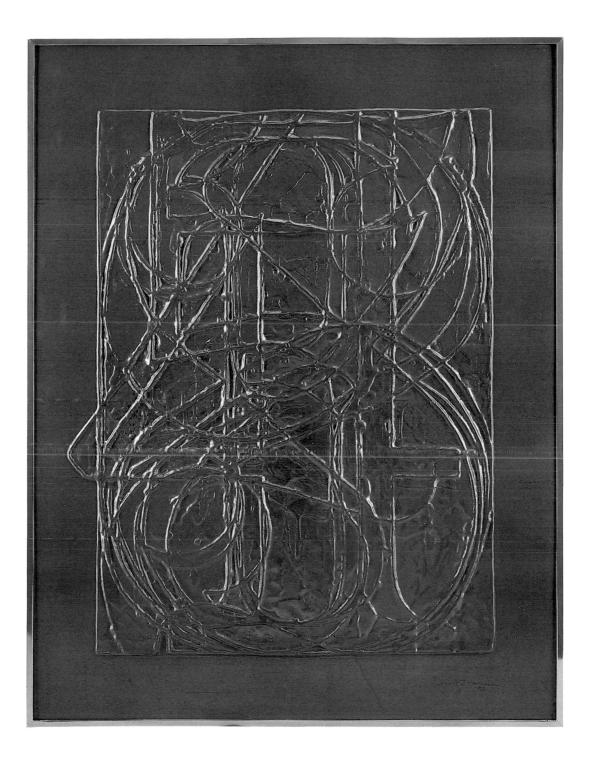

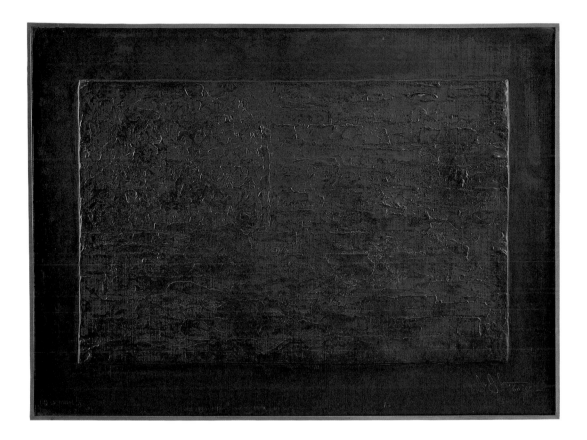

Flag 1969
lead relief
edition: 60
17 x 23
Printed and published by Gemini G.E.L.,
Los Angeles
Collection Walker Art Center, Minneapolis
Gift of Kenneth E. Tyler, 1985

X

Johns' art is one of renunciation. He has refused to accept conventional notions either about transcendence or about purity and perfection. He does not use art to color or escape life so that it might be made to seem more acceptable. Instead, he uses his understanding of materials and "symbolic things" to elucidate his awareness of the fissures spreading throughout the foundations of perception and being. Mortality, birth and dissolution, identity and anonymity, recognizability and invisibility the basic facts of our existence—are the subjects of Johns' work. Since he first integrated a flag and encaustic in 1954, his goal has been nothing less than uncovering the literal truth contained within the mind and body he inhabits.

> John Yau is a poet and critic whose most recent book is *Radiant Silhouette: New and Selected Work, 1974 – 1988* (1989), published by Black Sparrow Press.

1 Michael Crichton, *Jasper Johns*, exh. cat. (New York: Harry N. Abrams and Whitney Museum of American Art, 1977), p. 28.

2 Ibid., p. 27.

3 The remainder of the present essay is an expanded version of the author's "Homeless and Invisible: The Art of Jasper Johns," *Jasper Johns: Lead Reliefs*, exh. cat. (New York: Lorence-Monk Gallery, 1987), unpaginated.

4 John Cage, "Jasper Johns: Stories and Ideas," Alan R. Solomon, *Jasper Johns*, exh. cat. (New York: Jewish Museum, 1964), pp. 21 – 26.

Simca Print Artists: Usuyuki and Cicada
(1979 – 1981)

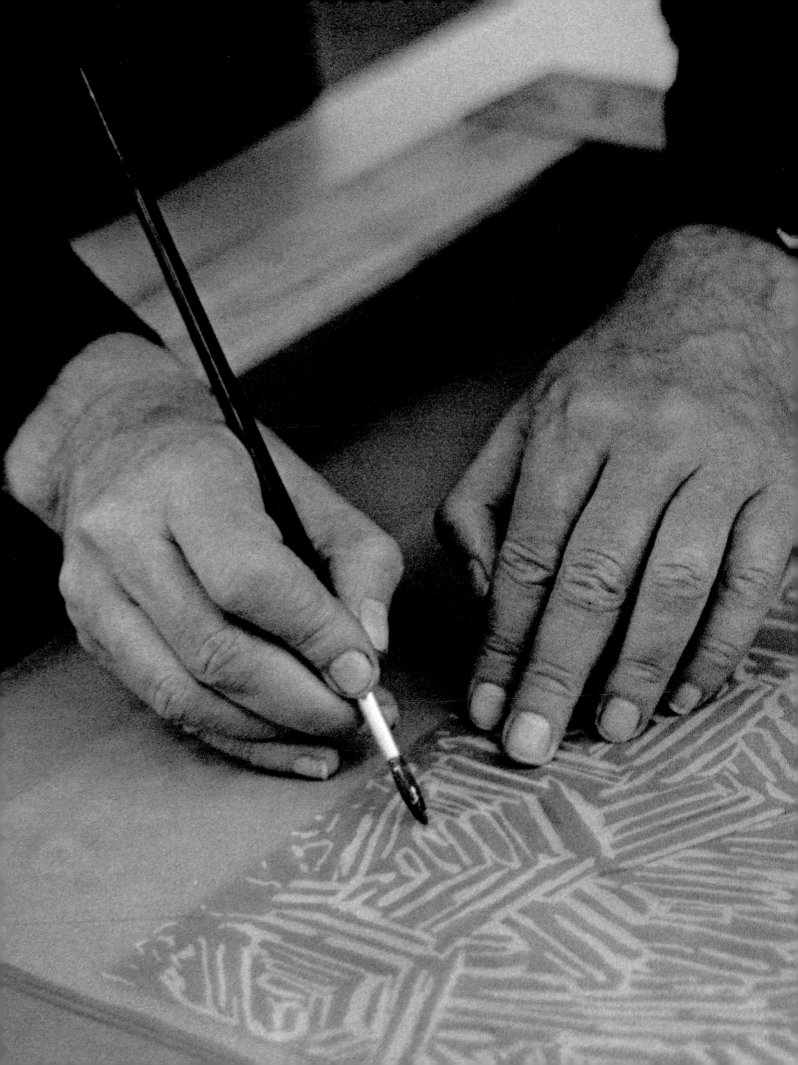

An Interview with Jasper Johns about Silkscreening

KATRINA MARTIN

The following interview was conducted in New York City in December 1980. It concerns Jasper Johns' screenprints *Usuyuki* (1979 – 1981, p. 56), *Usuyuki* (1980, p. 54), *Cicada* (1979, p. 53), and *Cicada II* (1981, p. 59), several of which were copublished by the artist and Simca Print Artists. The interviewer had been watching Johns work at Simca for several months while making her film *Hanafuda/ Jasper Johns* (1981, 34 minutes). Parts of this interview became the sound track of that film.

Katrina Martin: Can you describe the silkscreen process?

Jasper Johns: Well, somebody else could probably describe it better than I can. Basically it's a stencil. It's a positive and a negative, an opening through which paint is put that takes the shape of the opening of the paper.

KM: The reason I'd ask you to describe it is that I know you work in different media. How do you go about figuring out a medium?

JJ: Well, the medium expresses itself to you by what it is. Silkscreen, basically, is very simpleminded. It's simply an opening through which ink can go and be deposited on paper. And the fact that the silk is there allows you to have very complex openings that you couldn't simply cut out [of] a sheet of paper and have all the pieces hold together. But the silk supports these floating islands of material that block the ink, that don't allow the ink to go through.

KM: What's peculiar in the way you use silkscreen is that you don't use it to create areas that are flat.

JJ: But it is flat. That is its nature.

Johns modifies a screen for a Cicada print.

Cicada 1979
screenprint
edition: 100
22 x 18 1/8
Printed and published by Simca Print
Artists, New York
Collection Walker Art Center, Minneapolis
Gift of Judy and Kenneth Dayton, 1988

KM: But what's peculiar in the way that you're using it is that you build up a very complex and painterly kind of surface.

JJ: I understand that. But I think that might properly be considered an abuse of the medium (laughs). I'm not sure. Because what it does in its purest form is deposits an even coat of ink through an opening. There's never any breakdown in the amount of ink that's deposited in any place. It's always the same amount in every spot where it touches the paper. [It's] perfectly even. What I do, what I tend to do, is to first work freely with the brush on the screens, getting whatever shapes the brush makes. Then I tend with additional screens to reinforce those shapes. And that confuses a little bit the flatness of it and suggests a different kind of activity. But it's basically an illusion created by adding.

KM: The many layers?

JJ: Yes. Not just many layers but layers that mimic one another, so that many of the marks mimic the marks that are already there. So that instead of seeing two things you think you're only seeing one that's richer in some way.

KM: You don't get the same kind of accidents with silkscreen that you might get with other media.

JJ: What accidents do you refer to?

KM: Well, for example, variations in tone.

JJ: No, you don't get any variation of tone, unless you do it very deliberately by the way you color the ink. The ink going through the screen is always one quality and never varies—if you have a good printer.

Well, you get accidents to the degree that you can't imagine what something will look like, if you want to call that an accident. You think you will do something that will be a certain way, and then when you see it it's a little different. Usually I think my response is just a yes or a no to it, that that's all right or that's not all right. I don't know, it's subjective judgment. There isn't much to be concerned with, and there's not much room for accident. What accidents would you have? That things don't meet that are supposed to meet, or that things overlap that are not supposed to overlap. Well, that's very easily dealt with, that kind of thing. Because you only have ink and no ink. So you have the shape that the ink takes, and that's all you have. If you can imagine it properly, then there's no reason that you don't do it properly.

KM: How does imagining it properly take place?

JJ: I think it just amounts to jumping in and working and then continuing until you don't do it anymore. And then you say that that's your print.

KM: I see. You mean, in general with the print, or in general with the medium?

JJ: Well, you begin. And you work as long as your interest holds up. And if it interests you to change something, you can change it.

KM: How do you change it?

JJ: Well, in this, you can change the drawing, you can change the order of the screens, you can change the inks, you can change the gloss, the physical quality of it. Things like that.

KM: And when are you done?

AP 3/10 JJ '79

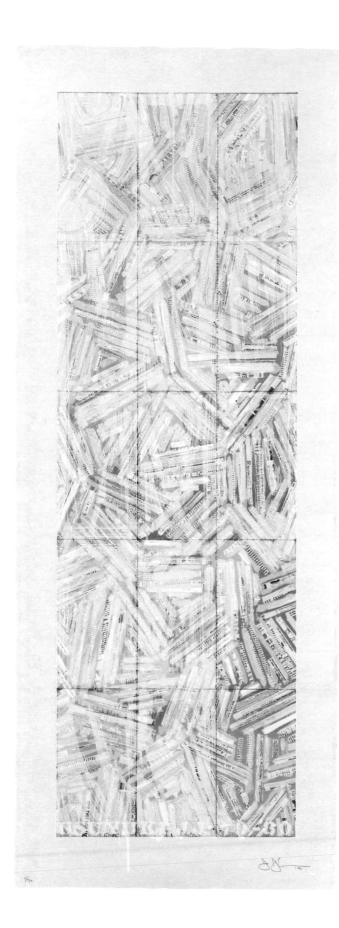

Usuyuki 1980
screenprint
edition: 90
52 x 20
Printed and published by Simca Print
Artists, New York
Collection Walker Art Center, Minneapolis
Gift of Judy and Kenneth Dayton, 1988

JJ: Well, sometimes when it looks hopeless to do anything more, sometimes you're done.

KM: Yes?

JJ: When your mind stops working in relation to the print. Basically that. I mean, when your mind stops working in relation to what you're doing, either you've finished it or you throw it away. Those seem to me the only choices.

KM: Can you describe what a hand-cut screen is?

JJ: A hand-cut screen is basically a sheet of film in which the parts that you want to print are removed from the sheet of film, and then the film is attached to the silk. Then the parts which have been cut out with a razor allow the ink to go through.

KM: And the screens made with tusche?

JJ: [With] tusche, you put waxy substance directly onto the silk. Then a material is pulled over that which becomes like the film, and where you put the tusche you wash out. Then you have an opening, so that what prints is the marks which you drew.

KM: Do you think you could describe how the tall *Usuyuki* print [1980] is built up?

JJ: There's a hand-cut stencil, which, if I remember correctly, follows a pasteup I did of strips of newspaper that form a kind of crosshatch pattern. Then we had made photographically a screen, which only had the type that was on the newspaper, that was printed in a kind of a black or gray. So with those two screens you get the effect of pieces of newspaper glued to or lying on the surface of the other paper.

KM: And then?

JJ: Well, I'm not sure I have the order right. Then those colored areas were put down. I'm sure there's a very simple way to explain that—usually with a squeegee you move ink across the screen, and a certain amount of the ink goes through the screen and is deposited on the paper. Usually you use one-color ink. And in laying down those flat areas, the ink was blended of more than one color, so that, say, instead of having a puddle of yellow ink pulled across, you had a puddle of ink that went from yellow to orange and was mixed.

KM: They were done in sections.

JJ: Well, that's partly because to do such a large thing would be very difficult to mix.

KM: At the vertical edges of those sections, the colors are almost the same but not quite.

JJ: Well, going to all that trouble to print it in five sections, I thought we shouldn't disguise the fact and should have it *not* match exactly. I thought it would be richer than hiding the fact that we were doing it in that way. There is the one idea that is suggested, that there's a smooth flow, a smooth color change from top to bottom. But literally it's not as smooth as it could be.

KM: And the color flow is a rainbow.

JJ: Yes, basically, a spectrum.

KM: This is a silly question, but why?

JJ: (pause) I haven't the slightest idea why (laughs).

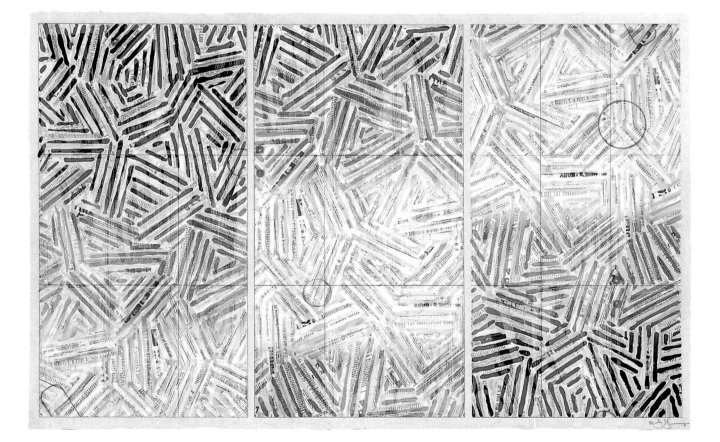

Usuyuki 1979 – 1981
screenprint
edition: 85
29 3/8 x 46 3/4
Printed by Simca Print Artists, New York
Copublished by the artist and Simca Print
Artists
Collection Walker Art Center, Minneapolis
Gift of Judy and Kenneth Dayton, 1988

KM: I knew that was the answer, but I thought I might ask …

JJ: These prints relate to other works, and I've thought about it so much that often something which has a function in one work is used in another work without the function that it had…. What I did [was] I made a study for the other Usuyuki print as a drawing, and I used kind of rainbow-colored inks to help me locate different things easily, and having done that I decided to use that kind of color in this print, just for itself…. For instance, the crosshatching in the three-panel painting [*Usuyuki*, 1977 – 1978] is moving in one direction. The grid, perhaps, is moving in a different direction. I think the grid and the little shapes are always moving in the same direction; I'm not sure. But you have several possibilities of moving, and in the drawings that I've done I've moved all these things in different ways and sometimes have colored them in ways that help me just keep it in my head what I'm doing, because it gets complicated.

KM: Could you talk about that more, how you move things in different ways in different drawings?

JJ: Well, if you have two systems, say the crosshatching and the grid, one of those systems, say, can move to the right and downward. This can go from the left down to the right and spiraling around. That's one system, say the crosshatching. Say, the other could move downward to the left. So if you make three representations of this, you will have different things meeting in the different pictures because they've been displaced. Say that you have one of the shapes, say the little circle, that's moving downward to the left, and the crosshatching down and to the right, the section of crosshatching that

meets that shape in one picture of this movement will meet a different section of crosshatching in the next picture of this movement. That's how you show the movement. That's what is being shown actually…. I've tried to do all the different possibilities in the drawings and things that I've done, just to see what it looked like…. What I wanted to do was to see what happened on the paper if I did all the different possibilities. Some of them are interesting because nothing happens, really. Some of the situations don't reveal what's happening actually.

KM: And that is the interest of an idea? That's what you sustain through the different prints?

JJ: Well, it's interesting to me. One hopes to have an image that is interesting in itself.

KM: See, I'm really asking maybe too broad a question, which is: Where does the image come from? How do you get an image where there wasn't an image?

JJ: Well, this comes from a thought, basically…. The thought has certain implications, and then if you try to deal with the implications, you have to do a certain amount of work…. I'm always interested in the physical form of whatever I'm doing and often repeat an image in another physical form just to see what happens, what the difference is. And to see what it is that connects them and what it is that separates them. Because the experience of one is rarely the experience of the other, for me, at any rate.

KM: You had a painting in the shop that you were working from in the Usuyuki prints, but there was no

Cicada II 1981
screenprint
edition: 50
24 x 18 1/2
Printed by Simca Print Artists, New York
Copublished by the artist and
Simca Print Artists
Collection Walker Art Center, Minneapolis
Gift of Judy and Kenneth Dayton, 1988

painting for the Cicada prints. Have you ever made a Cicada painting?

JJ: I've made several. Three, as a matter of fact. The one print is based on one painting; the other print is based on another painting.

KM: Why did you switch around the colors so much during the making of the first Cicada print [1979]?

JJ: Well, the two paintings I did, [in] the first painting the ground is white, the central colored marks are red, yellow, and blue, and the outer edges are the secondary colors, I think. Then I made a small painting and I reversed that, so that the white became a kind of dark gray and the secondaries were used where the primaries had been used, and the primaries were used where the secondaries had been used. And in working with the prints, I wanted to try the two other possibilities that occurred to me. One was to have the central area be the secondary colors [and] the outer edges be the primary colors on a field of white; and the reverse of that with the gray. Though I think I came back to the original situation in the print, didn't I? I'm not sure. I think the primaries run through the middle.

KM: You had it on different color papers. Were you really undecided at that point?

JJ: Well, one has the opportunity to try that kind of thing while working, and it may be something you would use and it may not be…. And actually you're looking before you're doing the edition, so that at any moment you could decide to have the edition be like that.

KM: But it's also the opportunity to see.

JJ: Yes, of course.

KM: For the two Cicada prints, I noticed that after the first edition was printed you altered the screens for the second edition. Why?

JJ: Well, because a dark shape on a light paper has a different quality than a light shape on a light paper. And because different colors of ink overlapping do different things, make different effects.

KM: So you'd have to alter the screens.

JJ: Not necessarily, but I think I did have to with that print. I don't remember how much altering I did.

KM: You basically changed the edges.

JJ: It probably has to do with the contrast between the dark ink and the white paper.

KM: The possibilities can become infinite.

JJ: I always think that what I do is much simpler than that. I do what I think to do, and that's about all there is that I can do…. Just the process of printmaking allows you to do—not *allows* you to do things but makes your mind work in a different way than, say, painting with a brush does. It changes your idea of economy and what is—what becomes of— a unit. In some forms of printmaking, for instance, it's very easy to reverse an image and suddenly have exactly what you've been working with facing the other direction and allowing you to work with that. Whereas if you were doing a painting, you would only do that out of perversity—you would have to have a serious interest to go to the trouble to do that.

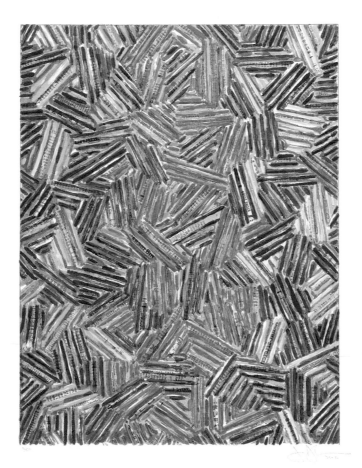

But in printmaking things like that become easy, and you may want to just play with that and see what it amounts to. Whereas if you had to do it in a more laborious way, you wouldn't want to give it that energy. Your curiosity wouldn't be that strong. There's a lot of that in printmaking. And some of that feeds back into painting, because then you see, you find things which are necessary to printmaking that become interesting in themselves and can be used in painting where they're not necessary but become like ideas. And in that way printmaking has affected my painting a lot…. Instead of smearing and slurring, you're to make it in steps [in printmaking]. And then, of course, the other interest goes into printmaking. It becomes very playful, because then you would like to try in printmaking something that isn't in its nature. That's that quality with the screenprinting that I think I tend to do, which I don't think is particularly appropriate.

> KM: How do you come up with a title?

JJ: Well, the Usuyuki—I came upon the word in something I was reading—and the word triggered my thinking. I can't do it in a kind of cause-and-effect relationship, but I know that's what happened.

> KM: Do you know what *usuyuki* means?

JJ: I think it means something like *thin snow*.

> KM: Why was that interesting?

JJ: (laughs) I don't know why anything is interesting, Katy. I think it has to do with a Japanese play or novel, and the character, the heroine of it, that is her name. And I think it was suggested that it's a kind of sentimental story that has to do with the—what do

you call it—the fleeting quality of beauty in the world, I believe. At any rate, I read this and the name stuck in my head. And then when, I think Madame Mukai was here once, and Hiroshi [Kawanishi] was here, and I had just read this, I'd been in St. Martin and read it, and I came back and I had dinner with them one night and I said, "Hiroshi, if I said to you, *usuyuki*, what would it mean?" And he said, "I think—very poetic—a little snow" (laughs). So I kept on and made my pictures using that title.

The Cicada title has to do with the image of something bursting through its skin, which is what they do. You have all those shells where the back splits and they've emerged. And basically that kind of splitting form is what I tried to suggest.

> KM: In this interview I've tried to talk about the specific images you've been working on, how they work, what their formal elements are, how you think about it technically …

JJ: Well, that's a very important part of it, but I think that might be better done by someone figuring that out rather than just casual conversation. Because it's a step-by-step thing, I think it would be better if someone figured it out and arranged it in their head and said it …

> KM: But even though you don't have to be the craftsman that the printers are, you have to have some idea of how things work just to bring an image into being.

JJ: I think you have to have a very clear idea.

KM: And then I wanted to talk something about meaning but …

JJ: About what?

KM: Meaning. In the work. But I wasn't sure how far to go with that. But I can't help thinking about meaning to some degree.

JJ: Well, you mean meaning of images? I don't like to get involved in that because I—any more than I've done—I tend to like to leave that free…. The problem with ideas is, the idea is often simply a way to focus your interest in making a work. The work isn't necessarily, I think—a function of the work is not to express the idea…. The idea focuses your attention in a certain way that helps you to do the work.

Katrina Martin is a painter and filmmaker who lives in New York City.

Atelier Crommelynck and Petersburg Press:
Target with Four Faces (1979)

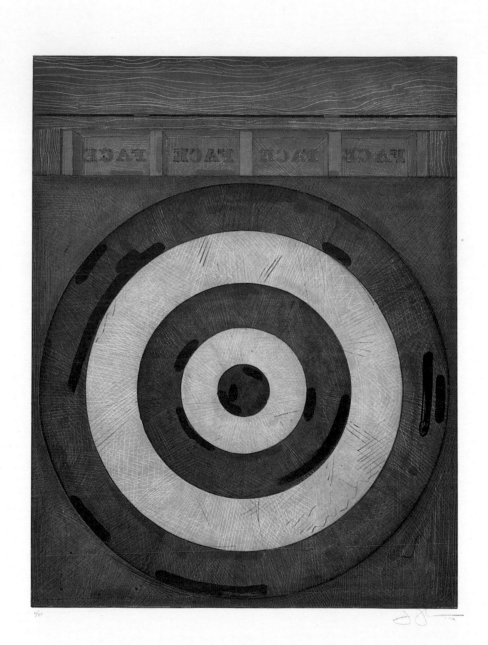

Translation and Transformation in *Target with Four Faces*: The Painting, the Drawing, and the Etching

CHARLES W. HAXTHAUSEN

Symbols grow. They come into being by developing out of other signs.... A symbol, once in being, spreads among the peoples. In use and in experience its meaning grows. Such words as *force*, *law*, *wealth*, *marriage*, bear for us very different meanings from those they bore to our barbarous ancestors. The symbol may, with Emerson's sphynx, say to man: "Of thine eye I am eyebeam."

— *Charles Sanders Peirce*

Basically, artists work out of rather stupid kinds of impulses and then the work is done. After that the work is used.... Publicly a work becomes not just intention, but the way it is used.

— *Jasper Johns*

It is one of the idiosyncratic and most often remarked aspects of Jasper Johns' prints that, with rare exceptions, they have been based entirely on his work in other media. Quite apart from the technical brilliance and variety of his graphic work, this characteristic is a source of its fascination. As early as 1964, when he had as yet produced fewer than fifty of his more than three hundred prints, the critic Alan Solomon wrote that Johns' "essential position ... has built into it infinite possibilities of variation."[1] Through the many changes his art has undergone since then, this has remained true.

Johns' prints have been described as "translations" or "variations" of his paintings and sculptures.[2] The artist has himself referred to them as a "transformation" of "images and ideas" developed in his paintings.[3] "I like to repeat an image in another medium to observe the play between the two: the image and the medium," he has said.[4] Johns has characterized his prints as a sort of commentary on the paintings on which they are based: "Aspects of the painting to which they refer seem to be illustrated or pointed to. Perhaps one senses that one is looking at one thing which is about another thing.... One can take an aspect of another work and exaggerate it, draw attention to it, give it an importance that it didn't have in the original work."[5]

p. 64
Target with Four Faces 1979
etching with soft-ground and aquatint
edition: 88
29 7/8 x 22 1/4
Printed by Atelier Crommelynck, Paris
Published by Petersburg Press, London
and New York
Collection Walker Art Center, Minneapolis
Gift of Judy and Kenneth Dayton, 1988

In the target motif—which, along with the flag, is the one most closely identified with Johns—we find a particularly rich example of this process. *Target with Plaster Casts* and *Target with Four Faces* (p. 68), both made in 1955, were among the artist's first mature works. Thereafter, over a period of more than twenty-five years, he returned to this motif over fifty times in different media and used it as the subject of thirteen of his prints.[6] Moreover, the target has a unique status within his printmaking: it was the motif he chose for his first essays in lithography (1960), etching (1967), and silkscreen (1968).

Given its central place in his oeuvre the target motif is a logical focus for a consideration of some of the larger issues of "translation" and "transformation" in Johns' art. This essay examines the relationships between three versions of *Target with Four Faces*: the painting with plaster casts, from 1955; the drawing made after it during the same year (p. 69); and the color intaglio print, combining etching, soft-ground, and aquatint, from 1979 (p. 64). The print has been noted for its unusual effects, even in a graphic oeuvre as technically diverse as that of Johns. One commentator has described its colors as "unusually jaundiced and impure";[7] another has written that "the image and its execution are so atypical of Johns that one thing is sure—it can't be a mistake."[8] These qualities, I shall propose, are indeed no mistake: they mark an incipient exploration of relationships that go beyond that play between the image and the medium characteristic of much of Johns' earlier graphic work, and as such they are part of a shift toward the more openly subjective imagery in his art of the 1980s.

In a 1965 interview with the British critic David Sylvester, Johns offered a concise summation of his critical stance toward painting as representation:

> I think I'm not willing to accept the representation of a thing as being the real thing, and I am frequently unwilling to work with the representation of the thing as, you know, as standing for the real thing. I like what I see to be real, or to be my idea of what is real. And I think I have a kind of resentment against illusion when I can recognize it. Also, a large part of my work has been involved with the painting as object, as a real thing in itself. And in the face of that 'tragedy', so far, my general development, it seems to me, has moved in the direction of using real things as painting. That is to say I find it more interesting to use a real fork as painting than it is to use painting as a real fork.[9]

Johns' early flags and targets, series that he began in 1955, are patently embodiments of this approach. First of all, they are not *representations* of individual flags or targets, presented in illusionistic space, but *exemplifications* of a conventionalized *type* of object, differing from other such exemplifications only in their unusual material construction. As the critic Leo Steinberg wrote in a classic essay, "you could throw a dart at a Johns target."[10] But Johns' flags and targets were also objects in the way in which they were made. They were not configurations created exclusively or even primarily out of pigment and binding medium, as are most paintings, whether representational or abstract. The stars and stripes and the contrasting concentric rings were made up of newspaper-collage elements that were dipped in wax and then applied during the painting process. *Target with Four Faces* was a palpable and self-sufficient structure, three inches thick, to which paint—red, yellow, and

blue on the target, orange on the plaster heads—was applied. Paint was therefore discrete from surface, reduced "to the status of a mere covering."[11] And he used the rapidly hardening medium of encaustic (pigments dissolved in hot beeswax), which served to preserve traces of the individual brushstrokes, to maximize this discreteness.[12] *Target with Four Faces* is therefore most accurately described not as a painting of a target but as a *painted* target, analogous to a painted chair or table, albeit infinitely more sensuous.

Although contributing to the experience of the target as an object, "as a real thing in itself," the casts have a different relationship to reality than the painted target proper. Even though we are inclined to regard each cast as a generic human face, they are not exemplifications of a conventional type of thing, as are the targets and flags, but four separate casts made from a particular woman; as such, they are no more artistic representations in any traditional sense than is a death mask.[13]

The radical novelty and internal consistency of Johns' painting emerge with striking clarity when his artistic practice is described in terms of the theory of signs developed by the American philosopher and logician Charles Sanders Peirce (1839 – 1914). Peirce, who described himself as a "backwoodsman" opening up the field of "semiotic," the study of signs, proposed that there were three general categories of signs—icon, index, and symbol—which he defined according to the way in which each relates to its respective object, i.e., to that which it signifies.[14] Icons relate to their object by virtue of some resemblance; anything that signifies its object by imitating some quality or aspect of it is an icon. "The icon has no dynamical connection with the object it represents," explained Peirce; "it simply happens that its qualities resemble those of that object, and excite analogous

sensations in the mind for which it is a likeness" (2:299). A diagram would be an icon, as would a representational painting or sculpture, insofar as they are viewed simply as mimetic images.[15]

The second type of sign, the index, relates to its object by means of a direct factual or causal relationship. As Peirce put it, "An index is a sign which refers to the object that it denotes by virtue of being really affected by that object" (2:248). A footprint, a weathervane, a knock on the door, a barometer reading, a clap of thunder, are all indices (2:285 – 287). An index—any kind of imprint, for example—may resemble its object, but that is not the primary basis of its relationship to it. A photograph, despite its illusionism, is for Peirce primarily an index rather than an icon because, unlike a painting, it is "physically forced to correspond point by point to nature" (2:281).

The third type of sign, the symbol, signifies its object by virtue of convention, rule, or code: "All words, sentences, books, and other conventional signs are symbols." Strictly speaking, symbols refer to a kind or class of thing rather than to a single object. For example, the word "man," Peirce explained, is only a "*replica*, or embodiment of the word. The word itself has no existence although it has a real being, *consisting in* the fact that all existents *will* conform to it" [Peirce's emphases]. Such conformity allows the word, or any other symbol, to be interpreted by those familiar with the convention as having a certain meaning (2:292).

According to Peirce, these three types of signs are not mutually exclusive. A photograph, for example, although an index, clearly has an iconic dimension; as does an onomatopoeic word, even if it is essentially a symbol. As an illusionistic image of thirteen men gathered at table,

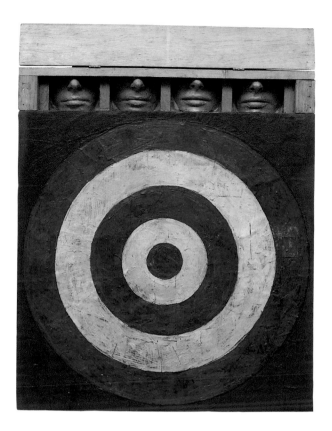

Target with Four Faces 1955
encaustic and collage on canvas with
objects, in wood box
33 5/8 x 26 x 3 overall, with box open
Collection The Museum of Modern Art,
New York
Gift of Mr. and Mrs. Robert C. Scull

Leonardo's *Last Supper* is an icon, but insofar as the viewer must be familiar with an iconographic convention to recognize its religious subject matter, it is a symbol. And Peirce conceded that it would be "difficult if not impossible ... to find any sign absolutely devoid of the indexical quality" (2:306). All paintings are indexical signs on the level of their execution, although the emphasis on the indexical can vary enormously. In a trompe l'oeil painting by John Frederick Peto the indexical is virtually concealed in favor of the iconic; in a Jackson Pollock drip painting, on the other hand, the index becomes the predominant mode of signification, and the iconic is reduced to a minimum.[16] But despite the presence of multiple modes of signification within a given sign, in every case one mode of signification "predominates over the others."[17]

In the painted version of *Target with Four Faces*— despite the recognizability of its motifs—the predominant modes of signification are indexical and symbolic rather than iconic. What this means in common critical jargon is that *Target with Four Faces* is paradoxically figurative without being representational in the usual iconic sense of that term; this contributed to the radical novelty of Johns' work in the late 1950s. True, the face has a resemblance to a human face, and if that were the primary basis of its signification, it would be an icon. But

it is an index, since a cast, like a photograph, "denotes its object by virtue of its being really affected by that object." The target (like the flag and the contemporaneous alphabets and numerals) is a symbol; its identity as a target is based on a convention—without this convention they would be merely concentric rings, like those in Kenneth Noland's circle paintings of 1958 – 1962. At the same time, in their richly encrusted surfaces and conspicuous brushwork, all of Johns' early works vigorously assert the indexical.

The artist summed up his practice during these years in an often-quoted sketchbook note: "Take an object. Do something to it. Do something else to it."[18] The objects Johns "took" were conventional signs—symbols; what he "did" to them was indexical. And, as he developed away from using symbols as compositional motifs, he continued to avoid the iconic, while the indexical took on ever more varied forms in his art: tracings, imprints of objects and of parts of the body, and the incorporation into the painting of implements used in making it.[19]

The drawing Johns made after *Target with Four Faces*, also in 1955, must have appeared less shocking than the painting, but in its own way it is an equally curious artifact.[20] Employing the conventionalized style of mechanical drawing and showing the work frontally and in

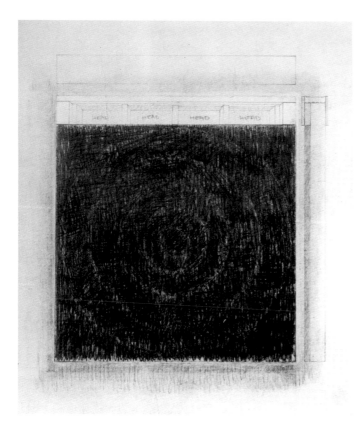

Target with Four Faces 1955
graphite on paper
8 1/2 x 7 1/4
Collection the artist

profile, it is best described as a *rendering* of the painting. It is a schematic denotation of a three-dimensional entity on a two-dimensional surface. Thus it is not a thing of the same kind, presented in a different medium, but a different kind of thing. For one, it is a *representation*, an icon of a specific target—an anomalous one with four faces—rather than being yet another replica of a target as a kind of object. And in contrast to the painting, where Johns excluded anything that could be considered illusion, he here drew the compartments along the top of the painting in flawless perspective. The plaster heads, consistent with Johns' avoidance of the iconic, are here denoted not by drawings but by the word *head*, inscribed in each of the four compartments.[21] An index has been translated into a symbol.

This change suggests that it would be mistaken to view the drawing merely as a reductive, totally *subservient* denotation of the painting. Johns seemed to be equally intent on demonstrating the contrasting natures of the two media as he conceived them. In this drawing he juxtaposed two conventional applications of graphic denotation—as diagram (icon) and as script (symbol). But in the dark, dense monotone face of the target he was also intensely involved with the graphic as index, as *marking*. Except for retaining a faintly discernible concentric pattern, which in the painting had been con-

structed by means of collage, Johns did not differentiate the rings. It is as if the graphic medium were impervious to those qualities of painting articulated by color. What it translates from the painting is not the contrasting hues, which belong to the target's identity as a symbol; it renders the painted surface neither as color nor as value but as *matter*, as a *covering*, carried out in short, palpable strokes of pigment, and it thereby highlights the painting's indexical quality. It does so with a dense, sensuous fabric of pencil strokes that become a graphic equivalent of painterly *facture*. Thus does this early drawing exemplify that discursive function Johns later attributed to his prints: in it "aspects of the painting ... seem to be illustrated or pointed to."

The color etching *Target with Four Faces*, executed in 1979, combines features of both the painting and drawing of twenty-four years earlier. It repeats the color composition of the painting: the alternating blue and yellow rings framed by red, with orange filling the compartments along the top. It follows the drawing in the perspectival rendering of the boxes and in the substitution of a word for the indexical plaster cast; here *face* is used instead of *head*, reversed by the printing process.[22] At the same time, there are qualities here indicating that very different rules are operative than in the two prototypes. Technically the print is of such complexity that, in

Painting with Two Balls I 1962
lithograph
edition: 39
26 5/8 x 20 1/2
Printed and published by Universal
Limited Art Editions, West Islip,
New York
Collection Walker Art Center, Minneapolis
Gift of Judy and Kenneth Dayton, 1988

contrast to the painting and drawing, it tends to conceal rather than parade its indexical features. Conversely, there is a degree of illusion in the etching not present in either of its sources. To be sure, in the drawing the compartments were rendered in perspective, but they retained the character of a schematic denotation; Johns made no attempt to introduce light and shadow. In the etching, however, there is an effect of illumination from the left; shadows are darker on the left side than on the right. This resort to iconic illusionism is even more striking in his attempt to simulate the woodgrain of the compartments and their hinged lid—another quality that is ignored in the drawing.[23]

•

With his turn to printmaking in 1960, the network of relationships in Johns' work became more complex. Just as drawings had been translations of paintings, prints now became translations of drawings, paintings, and even sculptures. The chain of signification was extended and enriched. Although his first lithograph, *Target* (1960), was hardly more than a transcription of an earlier drawing, he quickly discovered in lithography formal possibilities that were unique to printmaking. One was the possibility of variation through reworkings of the stone or plate and through printing with different inks on different papers. (Robert Rosenblum's commentary in the present book

on the early lithographic cycle 0 – 9 [1960 – 1963] deals with a now-classic example of Johns' ingenious exploitation of this possibility.) A second attraction printmaking held for Johns was the potential the medium offered for exploring his interest in maintaining that transparency of technique which had earlier led him to encaustic. "The tendency in printmaking is to think in terms of discrete operations and discrete objects," he told the critic Joseph Young.[24]

Although Johns was at first less enthusiastic about etching, as he gained mastery of it through his work with Aldo Crommelynck in Paris after 1974 he came to view it as the richest medium in terms of those qualities he valued most in printmaking. The copper plate "had the ability to store multiple layers of information. One can work in one way on a plate, later work in another way, and the print can show these different times in one moment."[25]

Yet printmaking had another feature that seemed, at least for a time, to bother Johns. As late as 1969 he called it an "unsatisfactory medium," which "suggests things changed or left out.... I don't really enjoy the idea that it's a reproductive process," he confessed, but he kept working at it, "trying to make it better."[26]

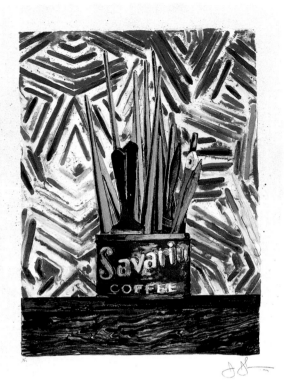

Savarin 1977
lithograph
edition: 50
46 1/2 x 35 1/4
Printed and published by Universal
Limited Art Editions, West Islip,
New York
Collection Walker Art Center, Minneapolis
Gift of Judy and Kenneth Dayton, 1988

This discontent with printmaking may have arisen in part from Johns' commitment to the work of art as object. In printmaking, unlike painting or drawing, the object to which one does things—the surface on which one makes marks—is not the work of art; the work of art is but an imprint of that surface. But he obviously found the challenge of printmaking rewarding, and his more recent remarks on the medium suggest none of his earlier reserve. Nevertheless, the reproductive nature of the medium, combined with his practice of using his own paintings as the basis for his prints, seemed to lead him to make concessions to illusionistic representation in printmaking even as he continued to resist it in painting. In a real sense, many of the prints became *icons* of the paintings. This is not the place to examine the variety and inventiveness of Johns' accommodation to the reproductive nature of printmaking, but it is clear that, in certain cases, he regarded the play between the non-iconic reality of the painting and the iconic illusionism of the print as a creative stimulus that enriched his visual language games.

I offer one example. During the 1960s Johns continued to incorporate three-dimensional objects into certain of his paintings even as he persisted in avoiding any depicted or illusionistic space in them. To translate such works into the print medium meant making some sort of accommodation to its flatness. The first print in which he confronted this issue was the color lithograph *Painting with Two Balls I* (1962; p. 70), which was also the first he printed from more than a single stone. The title itself unashamedly betrays the iconic nature of the print—it is not "Lithograph with Two Balls" but "Painting with Two Balls," named after the work of 1960. If the balls wedged in the slit between the two sections of canvas serve to activate it as a spatial entity and reinforce the painting's status as an object, in the print this conceit had to be rendered illusionistically: the two balls are represented in traditional chiaroscuro and lie flat on the unbroken surface of the Japan paper, within a "slit" bounded by two thick black lines. It might seem that the point of Johns' painting has been lost in its translation into lithography, but not really. For what seems a forced surrender to illusion is more likely a play with the reproductive nature of the new medium. The parting of the "canvas" exposes the virginal paper and establishes its oneness with the surface visible in the print's ample margins.[27] One senses the discreteness of image from support; that slender white cleft of Japan makes one acutely conscious of the image as something extraneous to that surface, conscious of its nature as an imprint. Far from being an unhappy compromise, the print makes a point analogous to that of the painting: each work demonstrates a physical fact about its medium that is usually concealed.

The illusionism in the upper section of the intaglio version of *Target with Four Faces* is of a different order, however. For here it is not merely volume but texture that is represented, so masterfully that even as a print it approaches trompe l'oeil illusionism.[28] Previously, in prints of paintings incorporating wooden elements, Johns had made no attempt to simulate the texture of woodgrain. Either he had ignored it, or he had obtained the woodgrain effect by inking strips of wood and transferring the ink onto the printing surface, as in the screenprint version of *Target with Four Faces* (1968) and the fourth print of *Four Panels from Untitled* (1973 – 1974).[29] However, the first print in which manually depicted woodgrain becomes a conspicuous feature is the large color lithograph he made in 1977, *Savarin* (p. 71). There the coffee can with paintbrushes, an image of Johns' *Painted Bronze* (1960), projects over a woodgrained table; behind it is a fragment of a hatch painting in the manner in which he was working at the time.

It might seem that Johns' sudden interest in simulating woodgrain in certain prints of the late 1970s is a minor aspect of these works. But the context in which this feature made its initial appearance suggests otherwise. *Savarin* was a *pièce d'occasion*, made to serve as the poster for his Whitney Museum of American Art retrospective of that year. Unlike the vast majority of his prints, this one is not based on a painting—it is an original image. It also marks a radical departure from his previous work in another way: not only is this print not an iconic sign of a *single* work of art, it also *juxtaposes two works* in such a way as to suggest a studio ambience. It is the first time, in either a painting or a print, that Johns represents a *place*, that a work of his has a relation to a place other than the one it occupies.[30] In this instance, the print anticipated by five years a major shift in his painting: in 1982, with *In the Studio*, his paintings

took a sharp turn toward the iconic as Johns began depicting walls on which various artifacts are juxtaposed. And, in a startling reversal, his paintings now included representations of his prints.[31]

He may have been stimulated to take this decisive step in *Savarin* by the idea of temporal distance that the print signifies. In this image made for his retrospective, "retrospection is the name of Johns' game and the obvious meaning of this lithograph," writes Richard Field. "Few images could so neatly symbolize past and present.... It seems to close the circle on a quarter century of art history as reflected in Johns's career."[32] I believe it is this temporal relationship between the two works that explains the prominence of the woodgrain, the only element in the image that is not a work of art. Woodgrain is an indexical sign of temporality; it is configured by the passage of the years, and its prominence in this print therefore seems entirely apposite.[33] Significantly, woodgrain pattern would later appear in each of the four paintings of The Seasons (1985 – 1986), a cycle that is overtly concerned with the theme of the passage of time.

In this context, both Johns' choice of motif and the prominence of the woodgrain in *Target with Four Faces* take on added significance. Like *Savarin*, this print appears to be strongly retrospective in nature. It is a painting revisited: the artist, about to turn fifty, looked back to a work he made at twenty-five, which, along with *Flag* and *Target with Plaster Casts*, was identified with his first artistic breakthrough and his emergence into the public eye. In *Savarin* Johns had conveyed the sense of temporal distance by a juxtaposition of works created at different moments in his career; now, in *Target with Four Faces*, he presents only a single work, but, with consummate virtuosity, he achieves an effect of temporal distance through purely *technical* means. Through a combination

of etching, soft-ground, and aquatint, using four copper plates, Johns created a rich, complex surface of extraordinary subtlety and density. The three plates inked with color, all of them containing etched lines and aquatint, were printed first; the whole composition was then over-printed in black, with a dense, intricate veil of aquatint covering the entire target area and giving the colors a muted, faded aspect, an effect accentuated by the spare touches of more saturated color. The surface is further enriched by a fine web of delicate hatchings in red, yellow, and blue, in which the underlayers of color glow through "negative" lines burnished into the aquatint on the black plate. For Judith Goldman, these unusual effects make the print appear "like some ancient artifact."[34] Riva Castleman relates that Johns had wanted the effect of a "tinted photograph."[35] The effect, however, is not one of deliberate tinting but of fading, of discoloration associated with age.

Johns' remark on the "tinted photograph" suggests that his approach in *Target with Four Faces* constitutes an *iconizing of the indexical*. Rather than asserting the print's own indexical nature, its own technical processes, as had his previous etchings since 1967, *Target with Four Faces* employs the intaglio technique for the purpose of illusion, to *simulate* other kinds of indices. In the trompe l'oeil woodgrain the index is part of the thing depicted; in the target area, Johns has striven to simulate effects of discoloration and abrasion that are normally indices of duration. Clearly, for all of its extraordinary virtuosity, this print is more than a play between image and medium, more than the transformation of a motif through technique. It is less about the relation between a painting and a print than about the relationship between a viewer and an artifact, a relationship informed by the experience of temporal distance. Certainly, the photographic analogy that Johns drew suggests this, and not only in the "faded" nature of the image. A photograph is also an index of a particular moment. As Roland Barthes wrote, "the photograph repeats what could never be repeated existentially." It is characterized by "spatial immediacy and temporal anteriority."[36]

But there is reason to believe that the 1979 etching, with its brilliantly simulated indices of temporality, may signify more than the aging of an artifact. The centrality of the target motif in Johns' art has already been noted; and precisely because of this centrality it has acquired a signification of a more personal kind. As early as 1961, shying out of a scheduled public appearance with Robert Rauschenberg, Jean Tinguely, and Nicki de St. Phalle at a Paris theater, Johns sent a floral arrangement in the design of his target as a substitute for himself.[37] This is a case of the growth of symbols noted by Peirce in the epigraph at the head of this essay. Through its use, not least by the artist himself, the target has evolved from being merely a conventional sign associated with games of marksmanship to being also a symbol of Jasper Johns and his art. As such, the intaglio version of *Target with Four Faces* may be seen as a meditation on mortality whose theme looks ahead to The Seasons.

Charles W. Haxthausen is an associate professor of art history at the University of Minnesota. He has written extensively on twentieth-century German art and is coeditor of *Berlin: Culture and Metropolis* (1990), published by the University of Minnesota Press.

1 Alan R. Solomon, *Jasper Johns*, exh. cat. (New York: Jewish Museum, 1964), p. 6.

2 See Richard S. Field, *Jasper Johns: Prints, 1960 – 1970*, exh. cat. (New York: Praeger and Philadelphia: Philadelphia Museum of Art, 1970), unpaginated; hereafter cited as Field 1970. See also Christian Geelhaar, *Jasper Johns: Working Proofs*, exh. cat. (Kunstmuseum Basel, 1979), p. 67.

3 Johns in a 1977 interview with Grace Glueck, as quoted by Riva Castleman, *Jasper Johns: A Print Retrospective*, exh. cat. (New York: Museum of Modern Art, 1986), p. 37.

4 Johns in Geelhaar, op. cit., p. 65.

5 Ibid., p. 67. See also Richard S. Field, *Jasper Johns: Prints, 1970 – 1977*, exh. cat. (Middletown, Conn.: Wesleyan University, 1978), p. 8; hereafter cited as Field 1978.

6 In her checklist of Johns' paintings and sculptures through 1974, Roberta Bernstein lists twenty-two targets (Roberta Bernstein, *Jasper Johns' Paintings and Sculptures, 1954 – 74: 'The Changing Focus of the Eye'* [Ann Arbor, Mich.: UMI Research Press, 1985], pp. 149 – 150). Although there is no comparable checklist for Johns' drawings, there must be at least an equal number of them for the same period. David Shapiro, in his book on the subject, reproduces twelve, dating from 1955 to 1981. See David Shapiro, *Jasper Johns Drawings: 1954 – 1984* (New York: Harry N. Abrams, 1984). So far as I can determine, the latest Johns target dates from 1981 and is a chalk version of *Target with Four Faces*; it is reproduced in Shapiro, pl. 142.

7 Castleman, op. cit., p. 45.

8 Judith Goldman, "Echoes—To What Purpose?" *Jasper Johns: Prints, 1977 – 1981*, exh. cat. (Boston: Thomas Segal Gallery, 1981), pp. 10 – 11.

9 David Sylvester, "Interview," *Jasper Johns Drawings*, exh. cat. (London: Arts Council of Great Britain, 1974), pp. 15 – 16.

10 Leo Steinberg, "Jasper Johns: The First Seven Years of His Art," *Other Criteria: Confrontations with Twentieth-Century Art* (New York: Oxford University Press, 1972), p. 42. On this point, see also Arthur C. Danto, *The Transfiguration of the Commonplace: A Philosophy of Art* (Cambridge, Mass.: Harvard University Press, 1981), pp. 83 – 84.

11 Max Kozloff, "Jasper Johns," *Renderings: Critical Essays on a Century of Modern Art* (New York: Simon and Shuster, 1969), p. 209. The article was first published in *The Nation* (16 March 1964).

12 See Johns' remarks to Michael Crichton in the latter's *Jasper Johns*, exh. cat. (New York: Harry N. Abrams and Whitney Museum of American Art, 1977), p. 28.

13 Johns had already employed a plaster cast of a head in a construction of 1954, *Untitled*, reproduced in Crichton, op. cit., p. 27.

14 Much of Peirce's writing on signs was not published in his lifetime. Although his earliest papers on the subject are from the late 1860s, his mature thought dates from the 1890s. These ideas are scattered in various manuscripts, which in the Harvard edition of his collected papers (see below, note 17) have in some cases been collated. A convenient digest of this material is included in an anthology of Peirce's writings edited by Justus Buchler, *Philosophical Writings of Peirce*, 1940 (reprint, New York: Dover, 1955), pp. 98 – 119. For an introduction to Peirce's contribution to a theory of signs, see Max H. Fisch, "Peirce's General Theory of Signs," *Sight, Sound, and Sense*, ed. Thomas A. Sebeok (Bloomington: Indiana University Press, 1978), pp. 31 – 70. For a general appreciation of Peirce's contribution to semiotics and its potential application to the visual arts, see Roman Jakobson, "A Glance at the Development of Semiotics," *The Framework of Language*, Michigan Studies in the Humanities, no. 1 (Ann Arbor: University of Michigan, 1980), pp. 7 – 12, 21 – 22. Although Johns has acknowledged his indebtedness to the thought of Ludwig Wittgenstein and James J. Gibson, I have no evidence of his familiarity with Peirce's semiotic theories. I am not claiming any direct influence.

15 *Collected Papers of Charles Sanders Peirce*, ed. Charles Hartshorne and Paul Weiss (Cambridge, Mass.: Harvard University Press, 1931), 2:276 – 280. (Subsequent references in the text refer to this edition. Consistent with established practice in the Peirce literature, the numbers refer to paragraphs of this edition rather than to pages.) Concerning icons, Peirce writes: "Every picture (however conventional its method) is a representation of this kind" (2:279).

16 In a pioneering essay that uses the term in Peirce's sense, Rosalind Krauss discusses the changing role of the index in modern and postmodern art. See her "Notes on the Index," parts 1 and 2, *The Originality of the Avant-Garde and Other Modernist Myths* (Cambridge, Mass.: MIT Press, 1986), pp. 196 – 219.

17 Peirce as quoted by Jakobson, op. cit., p. 11. See also Fisch, op. cit., p. 44.

18 Jasper Johns, "Sketchbook Notes," originally published in *Art and Literature* 4 (Spring 1965), here quoted from Suzi Gablik and John Russell, *Pop Art Redefined* (New York: Praeger, 1969), p. 85.

19 Richard Shiff has noted Johns' "penchant for the traced (or indexical) image, linked not to the style of a rendering but to the real object." See his article, "Anamorphosis: Jasper Johns," *Foirades/Fizzles: Echo and Allusion in the Art of Jasper Johns*, exh. cat. (Los Angeles: Grunwald Center for the Graphic Arts, Wight Art Gallery, University of California, Los Angeles, 1987), pp. 150 – 151.

20 Bernstein, op. cit., p. 19, confirms that the drawing was made after the painting.

21 This was the first time Johns would employ words in his art. See ibid.

22 In a drawing of 1958, *Target with Four Faces* (Shapiro, op. cit., pl. 24), Johns printed the word *face*. Nevertheless, in the precisely rendered perspective of the compartments, the etching resembles the 1955 drawing.

23 In his only other print version of this motif, the 1968 screenprint (Field 1970, 92), which shows the partial features of Merce Cunningham and a grainy raised lid, Johns used photographs of the choreographer and took the woodgrain from inked wood.

24 Joseph E. Young, "Jasper Johns: An Appraisal," *Art International* 13 (September 1969), p. 52.

25 Johns in conversation with Geelhaar, op. cit., p. 64. For his earlier, critical comments about this medium, see his remarks to Young, op. cit., p. 52.

26 Young, op. cit., p. 52.

27 On the importance Johns attaches to the margins of his prints, see Castleman, op. cit., pp. 15 – 16.

28 Trompe l'oeil woodgrain is of course a feature of Pablo Picasso's Cubist paintings and papiers collés of 1912 – 1914; so, on one level, this element could be construed as yet another of Johns' often-noted references to the Spanish artist. But as will become clear, I believe there may be other reasons for Johns' interest in this element.

29 Communication from the artist, 26 December 1989. So far as I can determine, the earliest instance of Johns' interest in manually *depicting* the texture of woodgrain can be found in *Foirades/Fizzles* of 1975 – 1976, in the etchings *Casts and Hatching* for Section 2 (Field 1978, 227), and *HandFootSockFloor* (Field 1978, 246) for Section 5. In neither case does one find the trompe l'oeil effects of the later *Target with Four Faces*, although proofs of the latter print indicate that Johns experimented with such an effect. See *Foirades/ Fizzles*, note 19, pls. 65 – 67.

30 In a conversation with Elizabeth Armstrong, 2 October 1989, Johns related that the drawing in pencil and crayon (*Savarin*, Shapiro 125), also executed in 1977, served as a preliminary study for the lithograph. It does not contain the woodgrain table. I am aware that the 1964 color lithograph *Ale Cans* (Field 1970, 47) might be considered a representation of a place. Representing Johns' sculpture of four years earlier, atmospherically modeled and in perspective, the work undoubtedly conveys an illusion of space. But the sculpture is seen in blackened isolation; there is no sense of its connectedness to a particular place.

31 Besides *In the Studio*, see *Perilous Night* (1982) and *Ventriloquist* (1983) in Mark Rosenthal, *Jasper Johns: Work since 1974*, exh. cat. (New York: Thames and Hudson and Philadelphia: Philadelphia Museum of Art, 1988), pls. 16, 17, 20.

32 Field 1978, p. 51.

33 It is also noteworthy that, in some subsequent lithographic versions of the Savarin motif, Johns replaced the wood with the imprint of an arm and the initials EM—a reference to Edvard Munch's 1895 lithographic self-portrait, in which a skeletal arm adorns the lower edge. The paradigmatic relationship between woodgrain and this veiled memento mori in the Savarin series would seem to reinforce the reading of the woodgrain as a sign of temporality. See Castleman, op. cit., p. 44. Woodgrain is also used to signify temporality in Anselm Kiefer's work from 1973 to 1980. See Charles W. Haxthausen, "Kiefer in America: Reflections on a Retrospective," *Kunstchronik* 42 (January 1989), p. 7.

34 Goldman, op. cit., p. 10.

35 Castleman, op. cit., p. 45.

36 Roland Barthes, *Camera Lucida: Reflections on Photography*, trans. Richard Howard (New York: Hill and Wang, 1981), p. 4; idem, "Rhetoric of the Image," *Image, Music, Text*, trans. Stephen Heath (New York: Hill and Wang, 1977), p. 44. See also Krauss, "Notes on the Index," part 2, pp. 217 – 218.

37 The story is related by Barbara Rose, "The Graphic Art of Jasper Johns, Part II," *Artforum* 9 (September 1970), p. 74.

ULAE: The Seasons (1987)

The Seasons:

p. 79
Spring 1987
etching and aquatint
edition: 73
26 1/8 x 19 1/8
Printed and published by Universal
Limited Art Editions, West Islip,
New York
Collection Walker Art Center, Minneapolis
Gift of Judy and Kenneth Dayton, 1988

p. 80
Summer 1987
etching and aquatint
edition: 73
26 1/4 x 19 1/8
Printed and published by Universal
Limited Art Editions, West Islip,
New York
Collection Walker Art Center, Minneapolis
Gift of Judy and Kenneth Dayton, 1988

p. 81
Fall 1987
etching and aquatint
edition: 73
26 1/4 x 19 1/8
Printed and published by Universal
Limited Art Editions, West Islip,
New York
Collection Walker Art Center, Minneapolis
Gift of Judy and Kenneth Dayton, 1988

p. 82
Winter 1987
etching and aquatint
edition: 73
26 1/8 x 19 1/8
Printed and published by Universal
Limited Art Editions, West Islip,
New York
Collection Walker Art Center, Minneapolis
Gift of Judy and Kenneth Dayton, 1988

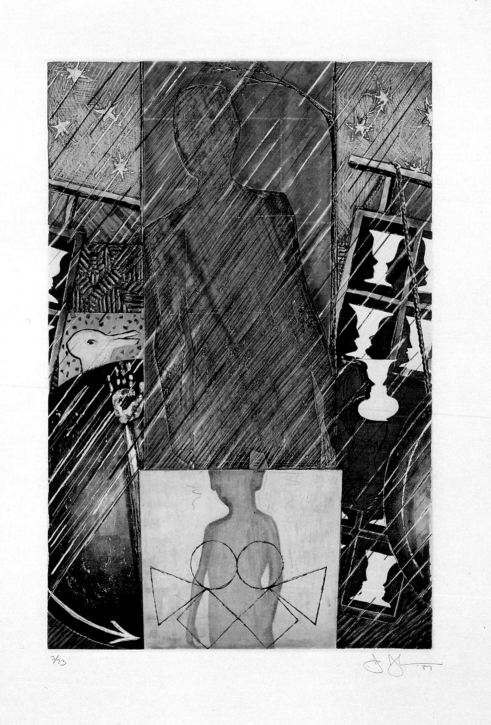

3/13 [signature] '87

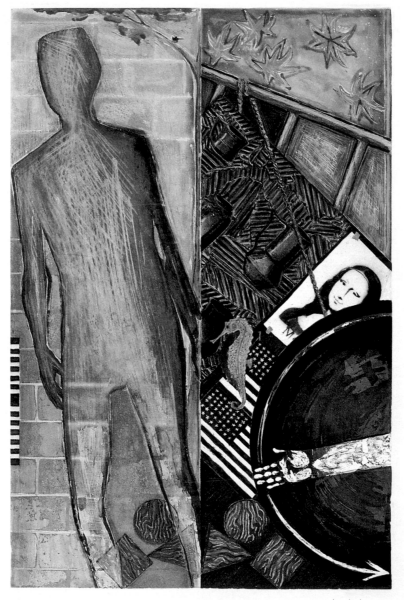

7/13 (signature) '87

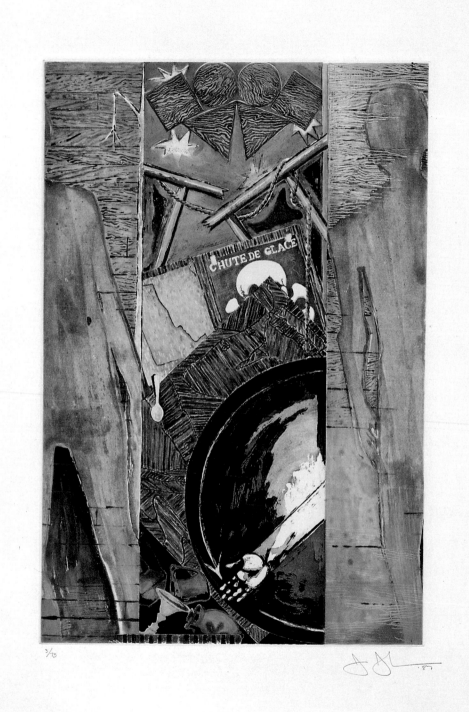

3/13 [signature] '8[?]

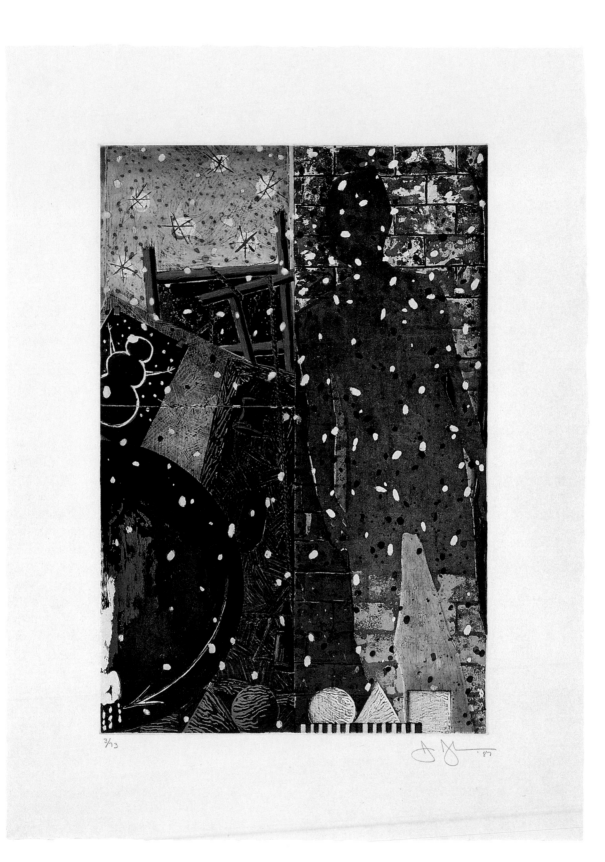

3/13 87

Reading The Seasons

JAMES CUNO

At the Leo Castelli Gallery in New York City in January 1987, Jasper Johns exhibited four paintings, seventeen drawings, and two prints culled from his two-year preoccupation with a single theme, the representation of the four seasons.[1] As critics were quick to point out, these works marked a significant departure in Johns' art.[2] Concerned chiefly with linear abstraction for the previous fifteen years, he was now mixing vivid iconographic elements—fragments of his recent paintings, pottery by George Ohr, a Swiss road sign warning of avalanches, a reproduction of the Mona Lisa, a rope, a ladder, a spoon, sheets from a psychological study of perception, and, above all, shadows of a man and child and numerous landscape elements—in an allegorical representation of the Ages of Man or the Four Seasons of Life.

Following this exhibition, Johns made four eight-color prints (pp. 79 – 82) that combine etching and aquatint to reproduce the imagery and descriptive effects of The Seasons paintings. These prints, and two recent variations on them, have prompted the writing of this essay. For they represent the artist's continuing involvement with a poetic theme of considerable pedigree in the history of art. And while much has been made of the "autobiographical" content of these paintings and prints, too little has been made of their cultural references, of the way Johns has referred to specific traditions in the art of the past and, in so doing, cast his art in the light of their meaning.

This is what is meant by the title of this essay: to consider the resonant implications of The Seasons' subjects, one must "read" them for their many references to what, despite the trendiness of the term, can only be described as a "text"—an accumulation of meanings gathered from a long tradition of representing the four seasons in art and literature. Whether the artist intended these meanings when making his paintings and prints is not the point. It is rather that, since they have been exhibited, published, and interpreted, The Seasons are no longer the artist's alone. They have been released into the larger context of culture, as it were, and have become part of the greater tradition within which they must now be read.

•

Critics and art historians have written much about the large shadowy figure in The Seasons paintings and prints. Judith Goldman has identified it as having been painted from a template of a tracing of Johns' own projected shadow.[3] Barbara Rose has noted that it falls across renderings of the flooring of the four studios in which he worked during the 1980s: St. Martin in the French West Indies (*Summer*), Houston Street (*Fall*), East 63rd Street (*Winter*), and Stony Point, New York (*Spring*).[4] And Mark

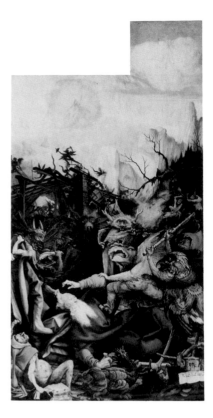

Matthias Grünewald (died 1528)
Temptation of St. Anthony panel from the
Isenheim Altarpiece circa 1512 – 1516
oil on panel
104 5/16 x 54 3/4
Collection Unterlinden Museum,
Colmar, France

Albrecht Dürer (1471 – 1528)
Melancolia I 1514
engraving
9 3/8 x 7 1/2

Albrecht Dürer (1471 – 1528)
Adam and Eve 1504
engraving
9 7/8 x 7 5/8
Collection The Fogg Art Museum,
Harvard University, Cambridge,
Massachusetts
Gift of William Gray from the Collection
of Francis Calley Gray

Rosenthal has pointed to the references in each Season to earlier paintings by Johns and to objects with which he is associated (the George Ohr pottery, for example, and the trick English vase that includes profiles of Prince Philip and Queen Elizabeth).[5] By these means, then, The Seasons refer back to the artist, his paintings, and his studios and can be described as autobiographical in content.

The Seasons also refer to the art of Pablo Picasso, however, specifically to his painting *Minotaur Moving His House* (1936), a reproduction of which Johns had come across when he was setting up his studio on St. Martin and was thinking of moving from Houston Street on the Lower East Side to another location in Manhattan.[6] By joining several motifs found in Picasso's picture—the wheeled cart, the ladder to which paintings are tied, and the flowery stars—to references to his own art and life, Johns associated his personal circumstances with the theme of Picasso's painting: the artist in transition, physically moving from one place to the next while contemplating a change in his art.

In addition to these references, the poet and critic John Ashbery has identified in The Seasons allusions to the Isenheim Altarpiece (circa 1512 – 1516) by Matthias Grünewald.[7] These occur in the fragments of striped paint-

ings, which recall earlier pictures by Johns in which he had embedded representations of the diseased figure from the altarpiece's *Temptation of St. Anthony* panel.[8] Significantly, the Isenheim Altarpiece was originally commissioned by an Antonite monastery that was part of a hospital order devoted to the tending of the sick.[9] According to an official history written in 1534, the monastery was dedicated to the care of those afflicted with "St. Anthony's Fire," a disease that included among its symptoms distended stomach, inflamed boils, and withered arms. A common treatment included amputation, which is suggested in The Seasons, perhaps coincidentally, by the artist's arm that swings in an arc through each painting.

Very recently, Nan Rosenthal interpreted Johns' allusion to the diseased figure in the Isenheim Altarpiece as a reference to Acquired Immune Deficiency Syndrome (AIDS), the disease that often marks its victims' skin with lesions before causing their death.[10] Indeed, Johns has included the diseased figure in a watercolor that also incorporates a representation of the 14 February 1988 *New York Times* headline "Spread of AIDS Abating/But Deaths Will Still Soar." But the allusion is more complex than this. It must also refer to the entire *Temptation* panel and to the representation of St. Anthony as steadfast in his faith despite the horrible torments inflicted

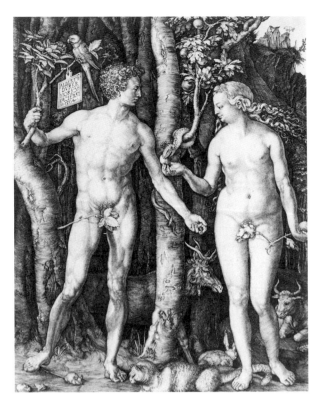

upon him—an emblem of humility conquering evil.[11]

Thus references to the Isenheim Altarpiece in The Seasons carry both topical and allegorical implications. This is also true of the references to Picasso's art. They signal both the artist's concern with his own circumstances—initiating change in his life and art at middle age, "the artist in search of coherence, wholeness, and continuity in a fragmented, discontinuous world"[12]—and his meditations on the larger meanings of change at particular moments in the Seasons of Life or the Ages of Man. Hence the ambiguity of the series' title, The Seasons: it is at once specific and general, descriptive and allegorical.

In this respect, The Seasons recall an earlier tradition in Western art in which descriptions of the visual world were seen to have profound philosophical dimensions. It has been suggested of the geometric shapes in The Seasons, for example, that they might refer to Albrecht Dürer's celebrated engraving *Melancolia I* (1514).[13] In his study of Dürer's life and art, Erwin Panofsky linked the title and subject of *Melancolia I* to the antique theory of the "four humors."[14] This theory was based on the assumption that the body and mind were conditioned by four basic fluids, which were coessential with the four elements, the four seasons, the four times of day, and

the four phases of life: choler (yellow gall) corresponded to summer, midday, and the age of maturity; phlegm was connected to winter, night, and old age; sanguine (blood) with spring, morning, and youth; and melancholy (black gall) with autumn, evening, and an age of about sixty. A perfect balance of these humors would indicate a healthy, immortal person, free of sin. But a twelfth-century Scholastic doctrine declared such a balance impossible. Adam's surrender to temptation and the resulting Fall of Man have left all men subject to illness, sin, death, and the imbalance of the humors.

One should also note that the theory of the four humors was linked to the story of Adam and Eve; and, in a suggestive way, as Johns' Seasons allude to Dürer's *Melancolia I*, they also refer to another of the German master's engravings, *Adam and Eve* (1504)—especially in the way the figure in each leans with his left arm extended out from his side and across the trunk of a tree, to the upper right of which is leafy foliage. But the paralysis of Johns' figures is more reminiscent of *Melancolia I*; they suffer what Panofsky called an "artist's melancholy: ... inactive not because she is too lazy to work but because work has become meaningless to her; her energy is paralyzed not by sleep but by thought."[15]

Thus by their references to Dürer, The Seasons depict

the melancholic artist suffering the black gall of doubt in a state of corrupted innocence. Nevertheless, the inactivity of the figure is given a positive cast in light of St. Anthony's posture in the *Temptation* panel of the Isenheim Altarpiece. For immobility can be a sign of steadfast faith, an inactive, unharmed stance against the temptations of the world; a triumph over evil, for which one is rewarded with paradisiacal peace and the regaining of innocence.

Such references to the art of the past are triggered in The Seasons by the prominence of the shadowy figure. It should be emphasized that the figure is not always treated the same in The Seasons paintings and prints. In *Summer*, for example, an etching made in 1985 as a frontispiece for a volume of poems by Wallace Stevens, the figure is broken up and bits of light are allowed to show through.[16] This is peculiar; for it would suggest that either the artist's body is similarly punctured, which of course it is not, or that the dark figural form is not a shadow. Indeed, it reads more like a shredded, discarded garment or the tattered remains of flayed flesh than a shadow cast from a body, such as one sees in the *Summer* painting. In *Winter*, an etching of 1986, the figure is white, with black snowflakes falling like holes perforating the tattered form; in the *Winter* painting the figure is a silver shadow cast upon the courtyard stones

of the artist's Upper East Side townhouse. And in the color etchings the figure in *Spring* is scarred, just as the figure is burnished in *Summer* and spotted in *Winter*; in *Fall* it is transparent to its knees and, around its face, is penetrated by the grain of the wood floor. All of these effects are apparent in The Seasons paintings, but they are emphasized in the color etchings. This suggests a heightening of the artist's concern with the surfaces of his shadow, and with the role it plays in the iconography of The Seasons.

In the recent etching *The Seasons* (1989), for example, white skeletal forms are apparent within the cast shadows. Similar forms, but now black, are evident in the drawing *The Seasons* (1989, p. 88). Here they recall the black stick figures in the lower-right margin of the drawing *Perilous Night* (1982).[17] These in turn recall the Picasso sculptures *Figure with a Javelin* and *Figure with a Spoon*, haunting, triballike figures made in 1960.[18] But what possible meaning could such figures have in The Seasons? One need only note that John Cage once described his 1944 composition *The Perilous Night*, from which Johns derived the title of his drawing and painting, as concerned with the "loneliness and terror that comes to one when love becomes unhappy."[19] It is a theme, therefore, most appropriate for the seasons, one that alludes, at least in English, to the original fall from grace and loss of

Summer 1985
frontispiece for *Poems* by Wallace Stevens
etching, aquatint, drypoint
edition: 320
17 1/4 x 12 1/8
Printed by Universal Limited Art Editions,
West Islip, New York
Published by The Arion Press,
San Francisco
Collection Walker Art Center, Minneapolis
Gift of Judy and Kenneth Dayton, 1988

Winter 1986
etching, aquatint, open bite
edition: 34
15 3/4 x 12
Printed and published by Universal
Limited Art Editions, West Islip,
New York
Collection Walker Art Center, Minneapolis
Gift of Judy and Kenneth Dayton, 1988

innocence—a loss suggested by the tattered and perforated forms of the shadowy figure in The Seasons etchings.

Given equal prominence with the figure in each image of The Seasons are the landscape elements, iconographic motifs never before apparent in Johns' art. Like the figure, they have a long tradition in Western painting, and, by their grouping into "four seasons," they call to mind Nicholas Poussin's great series of that title (1660 – 1664) in the Louvre. In Poussin's pictures the representation of the seasons is given a specific philosophical dimension. The British art historian Anthony Blunt has shown how they draw upon pagan and Christian iconography to symbolize the harmony of the universe and the salvation of Man through death and resurrection.[20] Yet Poussin goes beyond the humanist conception of nature as something that man can control. For this artist, Nature is an immanent force—benign in spring, rich in summer, somber yet fruitful in fall, and cruel in winter—before which man is a miserable being.

In this respect, the depiction of the four seasons assumes a pastoral form, in which the subject is not Nature itself but man's relation to nature. The literary historian David Halperin has defined the pastoral as achieving significance by oppositions, by a set of contrasts, in which the golden age is set against the normative world.[21] The latter is a place of practical achievement, action, and concrete accomplishment, while the natural world is an expression of human feelings and dreams, a projection of one's desire for wholeness in the face of a broken and conflict-ridden reality. This is certainly true of the great cycle of poems by James Thomson, *The Seasons*, published in London from 1726 to 1730.[22] There the seasons present a dialectical relationship between civilization and nature in which the threat of impermanence is ever present, as by its sublime power nature threatens to control the progress of civilization.

All of this is not to suggest that Johns had it in mind to make paintings and prints of pastoral subjects. Yet he did place his shadowy figure in settings dominated by the forces of nature unleashed upon the artifacts of culture—the materials of his craft, his studio, signs of civilization. And the result is manifest impermanence: the ladder breaks, paintings and pottery fall crashing to the floor, and the artist's arm sweeps down to rest, hanging still, like the cast arm fragments in the painting *Perilous Night* (1982). The Seasons call to mind the rhetorical structure of the pastoral, and this long tradition informs our reading of Johns' recent paintings and prints.

•

To reemphasize the point made at the beginning of this essay, Johns need not have had it in mind to make paintings and prints of pastoral subjects, or to engage in the complexities of Scholastic doctrine. Nevertheless, by painting The Seasons and by continuing to refine his project through the subsequent prints, he was engaging his art with traditions of representation that have long and influential histories. His four-part cycle naturally calls to mind the allegory of the Ages of Man, the symbolism of the seasons, and the theory of the four humors and its relation to the Fall of Man. This is their larger context.

Johns' naming of the painting and print cycles indicates that he must have been aware of that context. He was, in effect, begging the comparison. In this connection, recall the comment he once made to the British art historian and curator Richard Francis: "Seeing a thing can sometimes trigger the mind to make another thing. In some instances the new work may include, as a sort of subject matter, references to the thing that was seen. And, because works of painting tend to share many aspects, working itself may initiate memories of other works. Naming or painting these ghosts sometimes seems a way to stop their nagging."[23]

They may stop nagging, but their voices are nonetheless loudly and clearly heard. For Johns has what T.S. Eliot would call a "historical sense," a way of working that links his art with the art of the past. It is what makes him, in the strictest sense of the word, a traditional artist. As Eliot wrote of poets, "This historical sense, which is a sense of the timeless and of the temporal together, is what makes a writer traditional. And it is at the same time what makes a writer most acutely conscious of his place in time, of his own contemporaneity."[24]

This historical sense is not without anxiety, however, for, as Eliot also wrote, the poet who is aware that the present is directed by the past "will be aware also that he must inevitably be judged by the standards of the past … a judgment, a comparison, in which two things are measured by each other."[25] And perhaps this anxiety is embodied in The Seasons by the figure, a shadowy trace of the artist himself, standing mute and melancholic as a transparent witness to the dialectic of nature and civilization working itself out over the course of the year and through the Ages of Man.

James Cuno is the director of the Hood Museum of Art, Dartmouth College. He curated the 1987 exhibition *Foirades/ Fizzles: Echo and Allusion in the Art of Jasper Johns* at the Grunwald Center for the Graphic Arts, UCLA.

The Seasons 1989
ink on plastic
24 x 58
Collection the artist

1 A fully illustrated catalogue, with an essay by Judith Goldman, was published to mark the occasion. David Whitney, ed., *Jasper Johns: The Seasons* (New York: Leo Castelli Gallery, 31 January – 7 March 1987).

2 Barbara Rose, "Jasper Johns— *The Seasons*," *Vogue* 177 (January 1987), pp. 192 – 199, 259 – 260.

3 Goldman, op. cit., p. 7.

4 Rose, op. cit., p. 259.

5 Mark Rosenthal, *Jasper Johns: Work since 1974*, exh. cat. (New York: Thames and Hudson and Philadelphia: Philadelphia Museum of Art, 1988), pp. 89 – 103.

6 Ibid., p. 89, n. 62.

7 John Ashbery, "Tortoise among Hares," *Newsweek* 103 (27 February 1984), p. 81. Jill Johnston has written of her tracking down of the precise reference to the Isenheim Altarpiece in "Tracking the Shadow," *Art in America* 75 (October 1987), p. 135.

8 These include *Untitled* (1983, Collection Mr. and Mrs. S.I. Newhouse, Jr.), *Racing Thoughts* (1983, Whitney Museum of American Art), *Untitled* (1984, Collection the artist), and *Racing Thoughts* (1984, Collection Robert and Jane Meyerhoff).

9 Andrée Hayum, "The Meaning and Function of the Isenheim Altarpiece: The Hospital Context Revisited," *Art Bulletin* 59 (December 1977), pp. 501 – 517.

10 Nan Rosenthal, "Drawing as Rethinking," *The Drawings of Jasper Johns*, exh. cat. (Washington, D.C.: National Gallery of Art, 1990).

11 See Ruth Mellinkoff, *The Devil at Isenheim* (Berkeley and Los Angeles: University of California Press, 1988).

12 Rose, op. cit., p. 260.

13 Ibid., pp. 259 – 260.

14 Erwin Panofsky, *The Life and Art of Albrecht Dürer* (Princeton, N.J.: Princeton University Press, 1971), pp. 157 – 163.

15 Ibid., p. 162.

16 Wallace Stevens, *Poems*, introduced by Helen Gardner (San Francisco: Arion Press, 1985).

17 Reproduced in Mark Rosenthal, op. cit., p. 68.

18 The two works were purchased in 1961 by Mr. and Mrs. Victor Ganz, in whose collection they remain. *Figure with a Spoon* was reproduced in *Art in America* 50 (1962), p. 92 (as *Woman with a Spoon*). Both were included in the 1967 exhibition *Sculpture of Picasso* at The Museum of Modern Art, New York; they are reproduced in pl. 150 of the exhibition catalogue. Mrs. Ganz kindly provided me with this information.

19 Quoted in Johnston, op. cit., p. 135.

20 Anthony Blunt, *Nicholas Poussin*, 2 vols. (New York: Bollingen Foundation, 1967), 2: pp. 331 – 333.

21 David M. Halperin, *Before Pastoral: Theocritus and the Ancient Tradition of Bucolic Poetry* (New Haven, Conn.: Yale University Press, 1983), pp. 61 – 70.

22 Thomson's poems were extremely influential. They provided the source for Haydn's oratorio *The Seasons* (1799 – 1801), which, with *The Creation* (1796 – 1798), has been described by the musicologist and pianist Charles Rosen as partaking of the pastoral tradition, supplying Haydn with "unequivocal solutions to the problem of setting a text which the late eighteenth-century religious style, corrupted by logical contradictions, was no longer capable of giving." See Rosen, *The Classical Style: Haydn, Mozart, Beethoven* (New York: W.W. Norton, 1972), p. 370. Thomson's poems also served as sources for paintings by Turner and Constable. On Thomson, see John Barrell, *The Idea of Landscape and the Sense of Place, 1730 – 1840* (Cambridge, England: Cambridge University Press, 1972).

23 Richard Francis, *Jasper Johns* (New York: Abbeville Press, 1984), p. 98.

24 T.S. Eliot, "Tradition and the Individual Talent," *Selected Prose of T.S. Eliot*, ed. Frank Kermode (New York: Harcourt Brace Jovanovich, 1975), p. 38.

25 Ibid., p. 39.

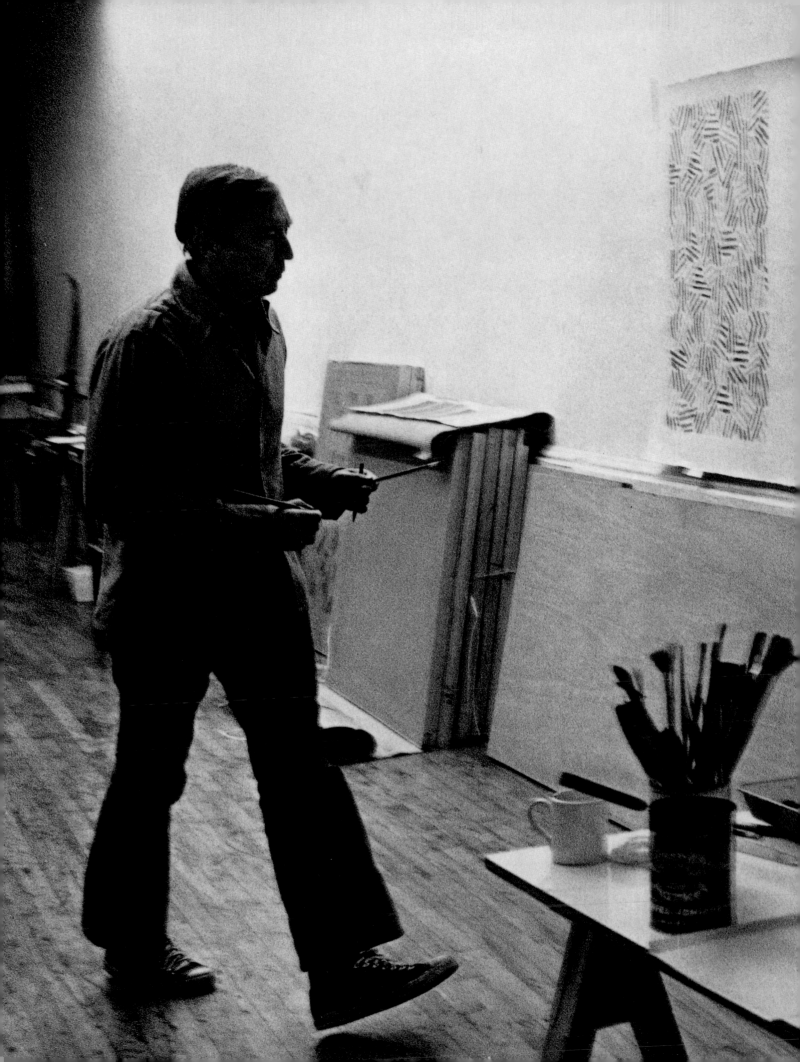

Lenders to the Exhibition

Judy and Kenneth Dayton
Jasper Johns
Margo Leavin Gallery, Los Angeles
The Museum of Modern Art, New York
Petersburg Press, London and New York
Stacy and Donna Roback, courtesy
** John C. Stoller and Co., Minneapolis**
Sonnabend Collection
David Whitney

Reproduction Credits

All photographs not otherwise credited
are by Walker Art Center.

pp. 2, 50: Katrina Martin, New York
p. 68: The Museum of Modern Art,
 New York
p. 69: Jim Strong, New York, courtesy
 Jasper Johns
p. 84: Giraudon/Art Resource, New York
p. 85: Marburg/Art Resource, New York
p. 85: The Fogg Art Museum,
 Harvard University, Cambridge,
 Massachusetts
p. 88: Dorothy Zeidman, New York,
 courtesy Jasper Johns
pp. 90 – 91: Hans Namuth, New York

Colophon

This book was set in Franklin Gothic and
New Caledonia typefaces. It was printed
at Litho Specialties, St. Paul, Minnesota,
on 100 lb. Lustro dull paper and was
bound by Midwest Editions, St. Paul.

Staff for the Exhibition

Director
Martin Friedman

Administrative Director
David M. Galligan

Exhibition Curator
Elizabeth Armstrong

Curatorial Associate
Joan Rothfuss

Curatorial Intern
Ann Brooke

Registrars
Carolyn Lasar
Jane Weisbin

Graphic Designers
Glenn Suokko
Susanna Stieff

Editor
Phil Freshman

Photographers
Glenn Halvorson
Peter Latner

Editorial and Secretarial Assistant
Timothy Peterson

Associate Public Relations Director
Karen Statler

Development Director
Kathleen Fluegel

Education Director
Margaret O'Neill-Ligon

Budget Supervisor
Mary Polta

Slide-Tape Producer
Charles Helm

Exhibition Installation
Lynn Amlie
Brian Bartholomay
Joe Chesla
David Dick
Stephen Ecklund
Ken Geisen
Laura Hampton
Mark Kramer
Ric Lee
Susan Lindemann-Berg
Kirk McCall
Owen Osten
Sandra Daulton Shaughnessy
Jon Voils

Overleaf:
Johns working at Simca Print Artists,
New York City, 1976.